Collins

se

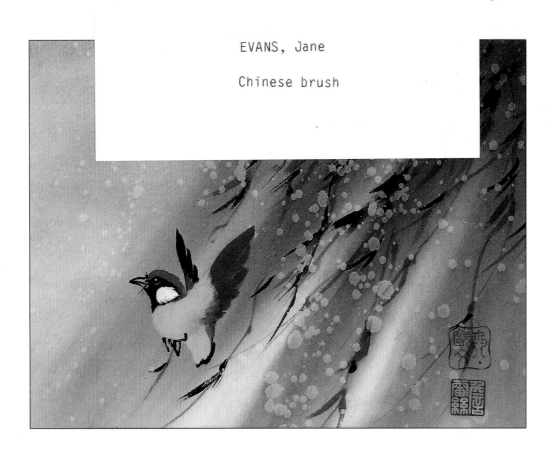

Jane Evans

ACKNOWLEDGEMENTS

My thanks to Nick Astbury for lending me the painting of Zöe on page 46 and
to Mr and Mrs Davey for letting me borrow the tiger painting on page 49.
I owe most of my knowledge about the symbolic meanings of plants and
animals in Chinese culture to a book called *Outlines of Chinese Symbolism and
Art Motives* by C.A.S. Williams (Dover Publications Inc., New York 1976).
My biggest thanks go, as usual, to my husband Martin for his continued
encouragement and always useful suggestions and comments.

First published in 1995 by Collins, an imprint of
HarperCollins*Publishers*
77-85 Fulham Palace Road
Hammersmith
London W6 8JB

The Collins website address is www.**collins**.co.uk

Collins is a registered trademark of HarperCollins Publishers Ltd.

06 08 10 09 07 05
2 4 6 5 3 1

© Jane Evans 1994

Jane Evans asserts the moral right to be identified as the author of this work.

A catalogue record for this book is available from the British Library

Editor: Flicka Lister
Design Manager: Caroline Hill
Design: Axis Design
Photographer: Nigel Cheffers-Heard

ISBN 0 00 719400 5

Printed and bound by Printing Express, Hong Kong

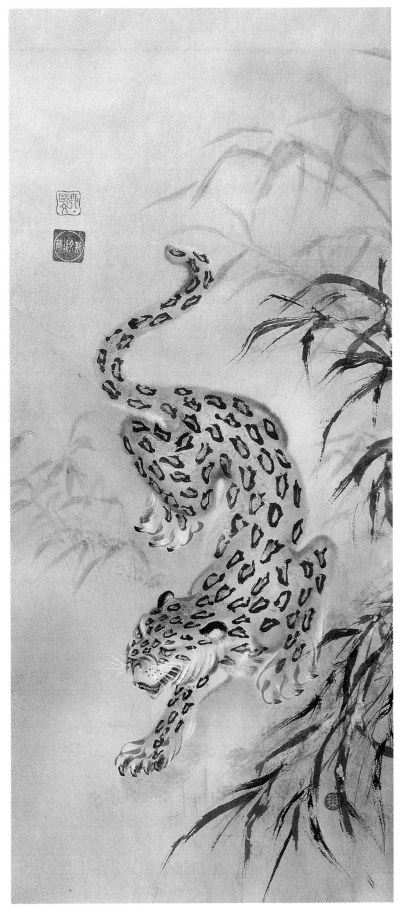

CONTENTS

PORTRAIT OF AN ARTIST
Jane Evans

After reading Archaeology and Anthropology at Cambridge University, Jane Evans moved to Papua New Guinea in 1972. There she became involved in the establishment of the national Creative Arts Centre, working as an administrator and editor. She also helped to organize the Third Niugini Arts Festival.

In 1975, Jane moved to the Philippines where she studied Chinese Brush Painting with Professor Chen Bing Sun, a leading exponent of the classical tradition, and with Hau Chiok and Sy Chua Hua, both freestyle painters of the Hong Kong based Lingnam school.

She returned to the UK in 1978 and continued to develop her painting, concentrating particularly on freestyle methods and working partly with Zen and Japanese Sumi techniques. An important objective in her work is to exploit the versatility of Chinese techniques and materials by using them in more adventurous ways, adapting a traditional Eastern medium to Western concepts of painting.

Jane has had several successful exhibitions, chiefly in London and East Anglia. In 1992 she won the Rosenstiel prize at the British Watercolour Society Christmas exhibition. She also does freelance advertising and design work as well as book illustration, and one of her advertising commissions was

▲ Jane Evans in her studio

awarded a certificate of distinction by *Art Direction Magazine* in the USA. Jane and her work have been featured several times on radio and television and she is a regular contributor to BBC Radio Cambridgeshire.

Jane has been teaching courses in Chinese Brush Painting in Britain and abroad since 1979. She also gives lectures, demonstrations, workshops and weekend courses and has made teaching videos. In 1996 she was invited to present a paper on Chinese Painting in the USA at a symposium held to celebrate the 250th anniversary of Princeton University.

Jane's first book, *Chinese Brush Painting: A complete course in traditional and modern techniques*, was published by HarperCollins in 1987 and has become a standard reference for aspiring brush painters. *Chinese Flower Painting*, published by the Search Press in their *Leisure Arts Series*, followed in 1990 and *Landscape Painting with a Chinese Brush: How to Paint Western Landscapes the Chinese Way*, published by HarperCollins, came out in 1992. Jane has also written articles for British and foreign art journals.

In 1998 she became a director of Cambridge Open Studios, one of the oldest and largest open studio movements in Britain, becoming Coordinator in 1999.

Jane, who is married and has two children, lives in Cambridge.

▶ Kingfishers with Splash
89 × 47 cm (35½ × 19 in)
The splash in this picture was done on damp paper, alternating dark tones with gouache white and blending them carefully.

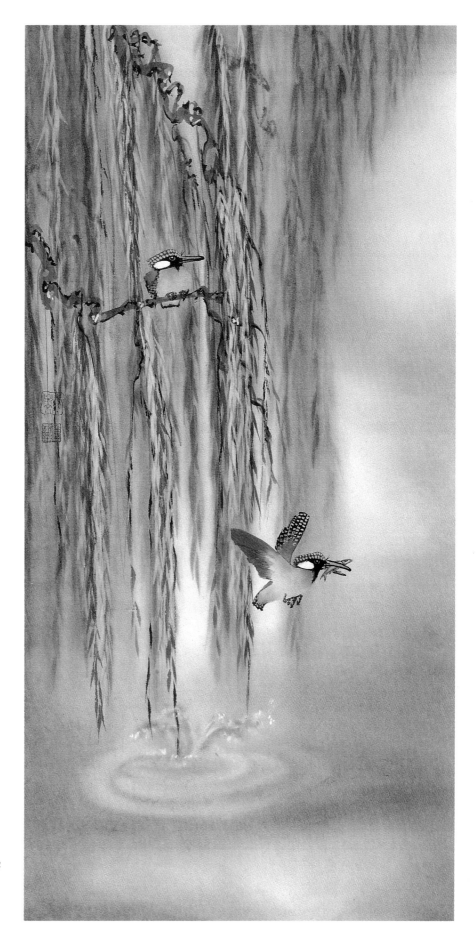

THE ART OF THE CHINESE BRUSH

Chinese brush painting is a versatile and expressive medium which offers Western artists a range of exciting, unfamiliar techniques and a fresh approach to composition.

Until recently, Oriental painting developed largely without influences from Western artistic traditions. The Chinese used brushes long before the dawn of their recorded history and they have been using them with paper for at least 2000 years.

The numerous styles of Chinese brush painting usually fall into either the Academic or the Literary tradition. Academic painting was originally the style of the court painters. Typically, it is detailed and painstaking with clean brush strokes and skilful colour blending.

The paintings in this book belong to the Literary tradition of freestyle painting, originally developed by scholars and monks, probably as a reaction to the Confucian formality of the Academic style.

◀ Duck
27 × 22 cm (10½ × 8½ in)
The head and the back of the duck are each formed with two strokes and the neck with one. The chest and stomach are also done in a single continuous movement.

THE *YIN* AND THE *YANG*

The main philosophical influence in Literary painting is Daoism, which teaches that creation is the result of the union of the *yin* and the *yang*. The *yin* is the negative, dark, moist, female force; the *yang* is the complementary positive, light, dry, male force. *Yin* and *yang* are harmonized by *chi* –

the manifest form of the *dao*, or innermost nature, that exists in everything. All things, animate and inanimate, behave according to their *chi* and it is this essential nature of his subject that the brush painter is striving to express on paper. A Chinese brush painting is thus not representational in the conventional sense.

I often tell an apocryphal tale that illustrates the difference: a Western painter and a Chinese painter were each given three days to produce a picture of a duck. The Westerner spent two days making detailed sketches of the ducks on his local pond. On the third day, he went to the pond and painted a portrait of a particular duck. The Chinese sat

by the pond for two and a half days without making a mark on paper. On the last afternoon, he went back to his studio and painted a picture that captured the essence of 'duckness'.

It is also from Daoism that Chinese brush painting gets its simplicity and its emphasis on the importance of space in composition. This simplicity has been reinforced by the traditions of Zen Buddhism and all three main Chinese philosophies have contributed to the contemplative nature of Chinese brush painting.

LIFE AND SPONTANEITY

In freestyle Chinese brush painting, the artist aims to depict as much as possible in the fewest possible strokes in order to maintain spontaneity and life. Brush strokes should be expressive and lively. Simple subjects, such as those shown on these two pages, should be completed 'in one breath' – the first stroke should still be wet when the last one is applied.

Before an artist can achieve this freedom, vigour and simplicity, and before he can convey the essential nature of his subjects, he needs to master technique and to understand his materials well enough to be able to concentrate on *what* he is painting and *why*, without worrying about *how*.

A Chinese brush is extremely versatile and the successful interplay between brush, ink and paper provides the painter with a wide range of effects and gives Chinese brush painting its spontaneous and dynamic quality.

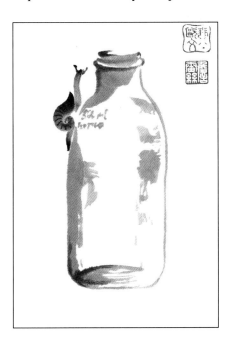

▲ Snail
28 × 19 cm (11 × 7½ in)
The shape of the snail consists of three strokes – one for the shell and two for the body.

▶ Fruit
42 × 22 cm (16½ × 8½ in)
Each fruit consists of no more than two strokes with the brush loaded with two colours at once.

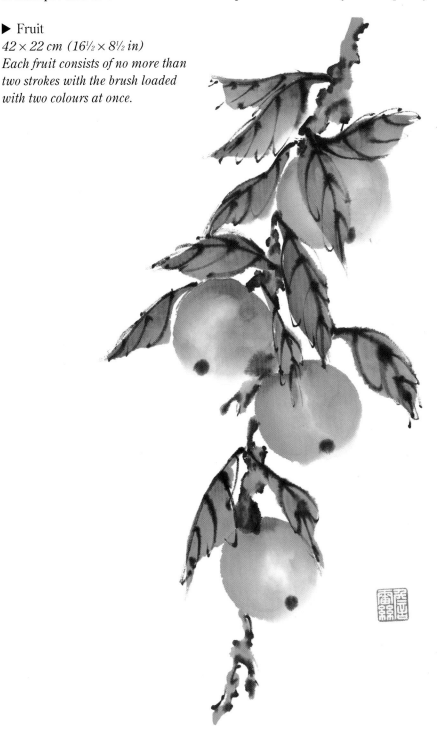

MATERIALS

Nowadays most good art shops carry a range of Chinese brush painting materials and there are several specialist suppliers who stock everything you could ever need.

The Chinese talk of the 'four treasures' of painting. These are the ink stick, the ink stone, the paper and the brush. There are also special Chinese painting colours although you can manage with gouache or watercolour to begin with.

CHINESE INK

Chinese ink normally comes in the form of an ink stick made of glue and either pine soot or lamp black. Buy a reasonably large stick of good quality as this will give you blacker ink. You can also buy bottled ink but this is difficult to get to the right consistency. It also contains less glue and is inclined to run when redamped.

INK STONES

The ink stick is reconstituted into liquid ink by grinding it on an ink stone with water. Ink stones are usually made of slate and two kinds are commonly available: oblong stones that have a grinding surface and a well for ink at one end; and circular ones which usually have a lid to keep the ink moist. You should buy as large a stone as possible.

PAPER

Unless otherwise stated, all the paintings in this book are on handmade, unsized *shuan* or *xuan* paper. This is usually sold in rolls of ten sheets or as large single sheets.

There are many Chinese and Japanese papers available and it is fun to experiment with different kinds. Continuous rolls of machine-made Japanese 'moon palace' paper are also widely sold. These are cheap and useful for practising on but machine-made paper does not take washes well.

Grass paper is very cheap and ideal for practising on but it is not very strong and tends to deaden ink and colour tones.

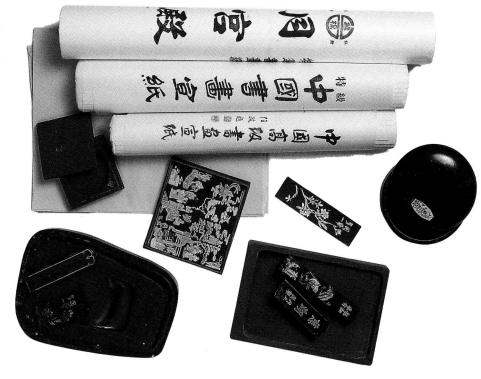

▲ *A selection of paper with ink sticks and stones.*

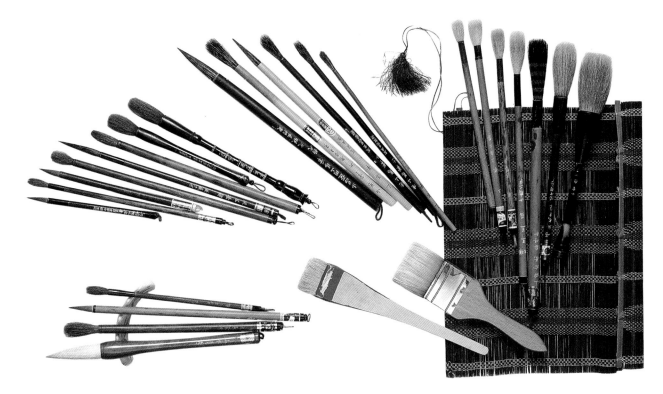

BRUSHES

A Chinese brush is constructed from carefully graded hairs. These are glued together at the base to form the head which is then glued into the handle. They come in three main types: soft, firm and coarse.

Soft brushes are usually white and are made of sheep or goat hair. These are the most expressive brushes as they respond most easily to pressure, although this can make them hard to control. They are often the cheapest and are easy to find in large sizes.

Firm brushes (the easiest for beginners to use) are normally light brown in colour. They are more resilient than soft brushes and spring back into shape after each stroke.

Coarse brushes are made of horsehair and are normally dark brown or black. They are used for creating rough-textured strokes. Coarse brushes are usually more expensive than other sorts of brushes.

In addition to these three main categories you can also buy semi-soft and semi-coarse brushes which are made from a mixture of hairs.

BASIC BRUSH KIT
There are four basic brushes that I recommend for beginners: a firm 'plum blossom' brush with bristles about 13 mm ($\frac{1}{2}$ in) long and 3 mm ($\frac{1}{8}$ in) in diameter; a firm or small 'orchid and bamboo' brush with a head about 30 mm (1$\frac{1}{4}$ in) long and 6 mm ($\frac{1}{4}$ in) wide; a firm or semi-coarse large 'orchid and bamboo' brush with bristles about 45 mm (1$\frac{3}{4}$ in) long and 10 mm ($\frac{3}{8}$ in) wide; and a large, (probably soft) brush with a head about 55 mm (2$\frac{1}{4}$ in) by 25 mm (1 in).

If you feel like investing in a coarse brush for rough effect strokes, buy a medium-sized one about 30 mm (1$\frac{1}{4}$ in) by 6 mm ($\frac{1}{4}$ in).

There is no need to buy very small brushes because any good

▲ *(From left to right): top row: selections of firm, coarse and soft brushes; bottom row: the four brushes I recommend for beginners, wash brush, mounting brush and brush mat.*

brush will give a fine line, regardless of its size.

All the sizes given are approximate. I cannot give numbers for brushes as there is no recognized system of grading by size and each manufacturer has his own idiosyncratic numbering method. Try to buy good-quality brushes – achieving a desired effect is easier with a good brush!

You will also need a 35 mm (1$\frac{1}{2}$ in) hake or wash brush and a 50 mm (2 in) firm bristle mounting brush.

Look after your brushes. Never recap a brush once you have washed the size off a new one. Always wash brushes in cold water immediately after use, hang them tip-down to dry, and transport them in a slatted bamboo mat.

COLOURS

Chinese painting colours have a high glue content and are made from mineral extracts, which are opaque, or vegetable extracts, which are translucent. Mineral colours are available in powder form and vegetable colours come as chips. Both can be bought in tubes or as ready-made cakes. Japanese-made Chinese painting colours, sold in individual dishes, are widely available and convenient to use.

Gouache is the closest Western equivalent to Chinese painting colour, although it is always opaque. I myself use a pot of gouache white. Watercolours can be used but these may run at the wash stage of a painting as they contain less glue than Chinese colours.

OTHER EQUIPMENT

You will need a table high enough to allow you to work standing when necessary. You should have a piece of felt in a neutral colour to place under your painting while working on dry paper, and an old blanket for use when you are doing a wash or working on damped paper.

You will also need a white ceramic palette with large sections, and paper weights to keep your work flat – and have some jars of clean water and a roll of kitchen towel handy.

I usually 'sign' my paintings with a 'chop' or seal carved with my Chinese name. Chops are usually of soapstone or bone and can be made to order if you want one with your name on it. You can also buy chops that are already carved with appropriate Chinese slogans.

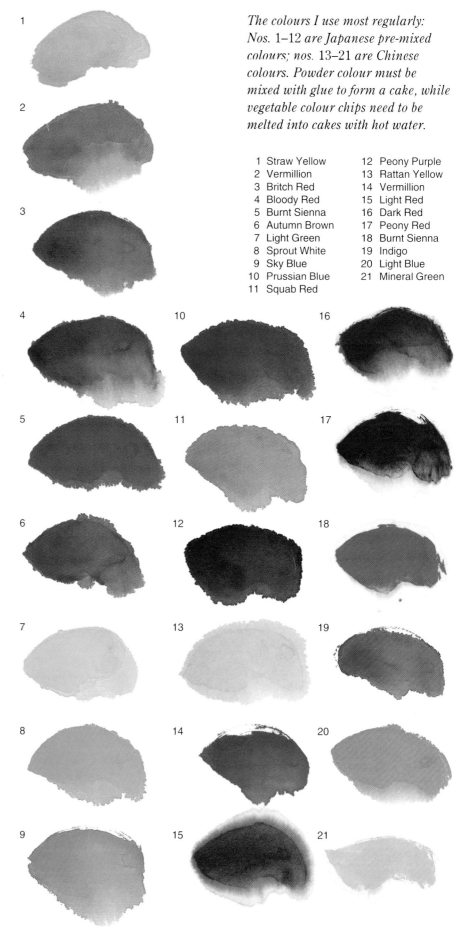

The colours I use most regularly: Nos. 1–12 are Japanese pre-mixed colours; nos. 13–21 are Chinese colours. Powder colour must be mixed with glue to form a cake, while vegetable colour chips need to be melted into cakes with hot water.

1 Straw Yellow	12 Peony Purple
2 Vermillion	13 Rattan Yellow
3 Britch Red	14 Vermillion
4 Bloody Red	15 Light Red
5 Burnt Sienna	16 Dark Red
6 Autumn Brown	17 Peony Red
7 Light Green	18 Burnt Sienna
8 Sprout White	19 Indigo
9 Sky Blue	20 Light Blue
10 Prussian Blue	21 Mineral Green
11 Squab Red	

BASIC TECHNIQUES

Chinese brush painting is traditionally learnt by mastering certain subjects in sequence. You learn each subject for its own sake but it is also teaching you skills you will need for the next. I have followed this time-honoured sequence here. However, it will be helpful to learn some basic strokes and to become familiar with the properties of the materials before you embark on the first subject.

GRINDING THE INK

The consistency and tone of the ink is very important. Put a small amount of water onto your stone with a brush or dropper and grind the end of the stick onto the stone with a firm circular movement. Continue until the water has absorbed as much ink as it will take.

Always keep the ink on your stone very thick and black. Never leave the stick in contact with the stone or it will bond to it. Also, remember to wipe your stone clean each time you finish with it, since a build-up of old ink impedes grinding.

▲ *To make ink that is still black but flows, transfer some ink to your palette and slacken with a little water.*

▲ *Create grey tone by taking very little ink and adding more water, being careful not to swamp the ink.*

▲ *If you want your grey tone to look dry, use very little ink so that you need hardly any water to lighten it.*

▲ *The lightest tone you will need is slightly darkened water.*

▲ *Put dark ink onto light ink to create a different 'broken ink' effect. You can also 'break' ink with colour.*

PAPER ABSORBENCY

Most oriental painting papers are considerably more absorbent than watercolour paper and I use unsized, and therefore very absorbent, *shuan*. Because of the paper absorbency, strokes that are done slowly spread. You therefore need to work fast for crisp clean strokes and slowly for misty or furry effects.

▲ *For this effect, dab the brush on the paper and lift it straight off again.*

▲ *Ink used straight from the stone should create this effect.*

▲ *For a 'broken ink' effect, put light ink onto dark ink while it is still wet.*

▲ *If you leave the brush in contact with the paper, the ink will start to spread.*

INK EFFECTS

Because the ink immediately bonds with the unsized paper, there are a few effects you need to know about and allow for (see below). The only way to avoid these effects is to work on pre-damped paper.

▲ *Whatever you paint first stays on top; the stroke painted second has sunk behind the first stroke.*

▲ *Even a stroke made with water will continue to show through ink that is laid over it.*

▲ *Every stroke will show up individually, as with these four strokes laid side by side.*

BRUSH STROKES

There are two methods of depicting a three-dimensional world in a two-dimensional medium. You can either outline and fill in or you can try to create shape without outline. Chinese brush painting uses both

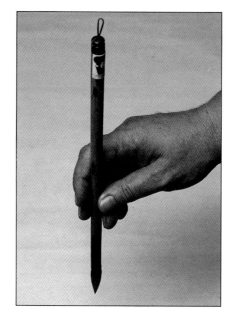

▲ *The correct brush hold. The thumb and the middle finger do the actual holding – the index finger just rests above the middle finger; the ring and little fingers are behind the brush with the thumb. Holding the brush in this way gives 360 degree control and enables you to wield it at any angle.*

methods, but a Chinese brush is uniquely adapted to help you to produce shape, texture and tonal variation simultaneously. Used incorrectly the brush is very difficult to control. However, if you hold, load and wield it in the right way, it is the most versatile tool available to the watercolour painter.

A brush can do a stroke that is as wide as the length of its bristles or as narrow as its extreme tip. It can also be splayed out to give a feathered stroke, used at any angle, and all or part of the brush head may be involved in a stroke.

Effects can also be created by altering the angle or pressure (or both) of the brush during a stroke and strokes can be either blunt or tapered; blunt strokes can be used to create a 'bone' effect. As the paper is so absorbent, tapered strokes must be begun and finished in the air. The brush can be used at any angle and the direction of a stroke may be reversed at the beginning or end of a stroke.

All the following exercises were done with a small 'orchid and bamboo' brush. Always use a brush that is large enough to achieve the effect you want in as few strokes as possible.

▲ *For a wide stroke, paint across the bristles with the whole of the brush head pressed onto the paper.*

▲ *Use just the extreme tip of the brush for a narrow stroke.*

◀ *For a feathered effect, use the tip of the brush but first splay it out by pressing it lightly against the palette.*

▶ *Practise continuous fluid strokes, doing each with the head at a different angle, with the brush alternately lifted and lowered.*
a *Stroking along the bristles.*
b *Stroking across the bristles at right angles.*
c *Stroking with the brush head at an angle of 45 degrees.*

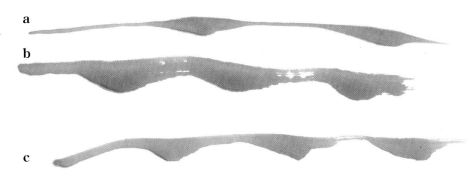

▼ *Push the brush against its bristles to create a rough textured stroke.*

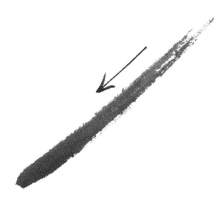

▶ **a** *For this 'bone' stroke, work along the brush head. To create a blunt effect, place the tip of the brush onto the paper and press down lightly, then move the brush along its bristles, pausing and pressing slightly before lifting it off at the end of the stroke.*
b *For a wider effect, work the stroke across the bristles.*
c *To create a different 'bone' effect, reverse the direction of the stroke just after starting it and again just before lifting the brush at the end.*

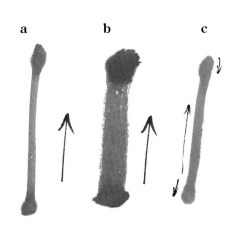

▶ **a** *For a tapered stroke, bring the tip of the brush down onto the paper, move it along and gradually lift it off in a single movement.*
b *Do the same action but use the brush across its bristles.*
c *Keeping your speed consistent, taper the brush along the bristles onto the paper, first gradually increasing the amount of head in contact with the paper and then decreasing it.*
d *Taper the brush onto the paper and immediately reverse, then taper off in the usual way.*
e *Taper the brush onto the paper in a straight line but reverse the direction at the end of the stroke.*

▶ **a** *Strokes can be blunt at one end and tapered at the other. Work along the bristles, pausing and pressing to blunt the start and tapering the end.*
b *This time, taper the brush onto the paper, across the bristles, and press down before lifting it off.*

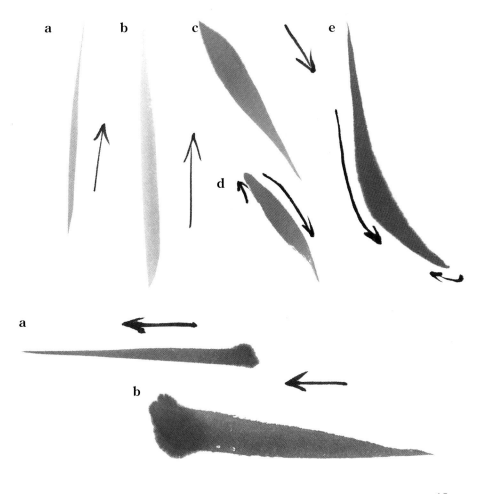

13

▼ *Often strokes are made by placing the brush onto the paper and pressing before lifting or tapering it off again.*
a *For this stroke, dab the brush tip gently onto the paper to leave a clear triangular impression.*
b *This time, lay the brush tip sideways onto the paper, press down lightly and lift.*
c *Start this stroke in the same way as b, but taper the brush off the paper across the bristles.*

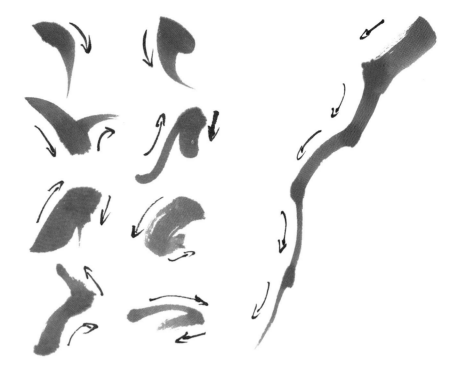

▲ *You can alter the angle of the head or change both the angle and the pressure during a stroke. All these strokes are variations on the ones already shown. In each case, however, you should turn the brush during the stroke.*

▲ *Begin this stroke with the brush head at right angles, turn it to 45 degrees at the first pressure point, and turn it again at the fourth pressure point to finish the stroke along the bristles.*

LOADING YOUR BRUSH

A Chinese brush holds a great deal of liquid. The base of the head acts as a reservoir for water, ink or colour and this allows you to load the brush with more than one ink tone or colour and to complete a branch or flower before redipping.

It is important not to have the ink too watery or the tones will run together on the brush. For fine detail, you should dry the heel of the brush and use just the tip. Even when you want the brush fully charged, it is usually necessary to wipe excess liquid off onto the side of the palette. On the other hand, if you have it too dry, the tones will not blend properly on the paper.

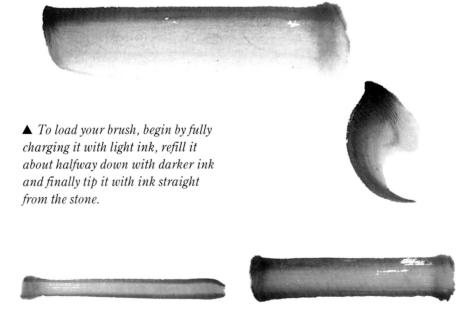

▲ *To load your brush, begin by fully charging it with light ink, refill it about halfway down with darker ink and finally tip it with ink straight from the stone.*

▲ *Dark tone can be stroked onto one or both sides of your brush.*

▲ *You can paint dark tone round the base of the brush head as well as applying it to the tip.*

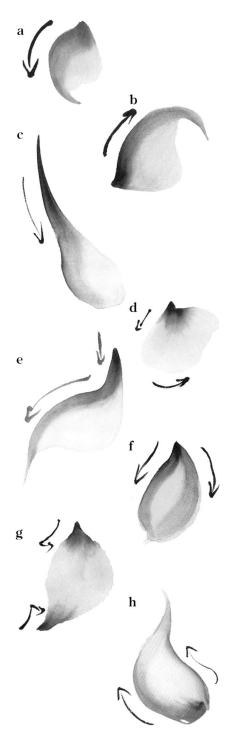

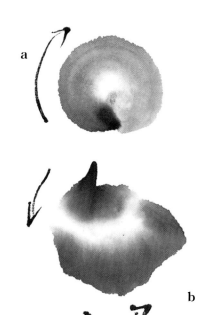

◀ a *For this petal, lay the full length of the brush onto the paper at the widest part of the petal and immediately pull it round in a curve, keeping the brush head at the same angle so that the stroke tapers off along the bristles.*

b *Make this petal with a similar stroke, worked upwards.*

c *Taper the brush onto the paper and pull along its bristles while gradually lowering the heel onto the paper.*

d *Gently taper the brush tip onto the paper and immediately press the heel down and move it gently sideways, keeping the tip still.*

e *Taper the brush onto the paper and press the heel down, moving it sideways in a curve, before tapering off the paper along the bristles.*

f *Do this petal in two strokes with the brush tapered onto the paper and pressed down before tapering off again.*

g *Begin with a stroke similar to the fourth petal, then reverse the brush and repeat the stroke upside down, to form the lower half of the petal. Curve the second stroke slightly.*

h *Point the brush downwards and lay the tip on the paper. Then swing the brush round so that the tip forms the left edge of the petal and the heel shapes the body. Taper the brush off the paper before repeating the stroke, rolling the brush the other way to form the right-hand side of the petal.*

▲ a *To create tonal variation, fill the brush with water, wiping off any excess, and place just the very tip into neat, thick colour. Roll the brush onto the paper, pressing down lightly with the heel.*

b *Fill the brush as you did for the previous petal and paint colour round the heel. Press the brush onto the paper and, keeping the tip still, move the heel slightly sideways as you did for the fourth petal above.*

USING COLOUR

As with the ink, it is important not to have your colour too wet. You can lighten a colour with water instead of white to preserve its translucency. However, the rule is less colour rather than more ink. In freestyle painting, colour is mixed on the brush, not on the paper. Load the brush with different colours in exactly the same way as you did with the ink tones. It is normally easier to load from light to dark as you did with the ink. Flower petals in particular should always be done with one or two twisted or angled strokes. Some typical petal shapes are shown here (above left). I used a large 'orchid and bamboo' brush, filled with straw yellow mixed with white and tipped with red.

Create tonal variation also by having clean water in the brush heel and thick colour on the very tip – the colour will bleed into the wet area left by the brush heel, as in the examples above right.

APPLYING WASHES

Because of their glue content and the absorbency of the paper, ink and colours bind strongly with the paper. Once a painting has dried, it can be redamped quite safely. The wash is therefore applied last of all.

This allows you to approach your subject with a directness denied to other watercolourists. You can begin with the most important element of the painting: the flower head before the leaves; the birds before the branch; the foreground of a landscape before the distance.

DAMPING THE PAPER

For any wash, lay your painting on a blanket or thick piece of felt and damp it evenly all over with a hake brush or, preferably, a fine spray. I usually work with two brushes: either a hake or a large soft brush to apply colour and a clean hake brush to ensure even spreading.

You can work on the front or back of the picture. Working on the back avoids any danger of the paper 'pilling' or of any white in the painting being deadened. However, it can be difficult to think back-to-front when the wash is a major element of a composition.

If you can achieve an even covering of colour over a painting you should have no difficulty with any other effects. In the painting above, my wash colour

was a mixture of burnt sienna, autumn brown and straw yellow, applied to the back of the painting.

The paintings on pages 25, 27 and 33 show examples of simple washes where the colour was faded out in areas. The method is essentially the same – don't apply colour over the whole painting and take extra care to spread the colour fully so that there are no sudden edges or streaks. Then, after spreading the colour as fully as possible, blend over the lighter areas with a clean hake brush.

▲ *For this wash, damp the paper and then fill a 25 mm (1 in) hake brush very sparingly with colour. Brush the colour onto the paper using light, firm, even strokes and spread the brushload as far as it will go. Then repeat the process, applying the new brushload over the area with colour on it and spreading it further out. Each brushload should overlap with and extend the coloured-in area until the whole painting has an even covering. See the section on painting birds on page 32, to find out how to paint feathers.*

PAINT EFFECTS

Painting with an ordinary brush onto damped paper gives you access to many effects. For example, you can create an impression of distant flowers, (see the painting on page 31) or you can give shape to rocks (see page 56) and add clouds and water (see pages 34 and 39).

Damping the paper removes the need to work fast and you should take time over any wash or wet paper effect. However, make sure that the paper is not drying as you work and respray it if necessary. If wet spots appear where the paper is sticking to the blanket, gently lift the painting and mop underneath to prevent permanent marking.

If you get a great many wet patches, your paper is probably too wet – it needs to be evenly damped not swamped – or, possibly, your blanket or felt is unsuitable. Always remember that paper is extremely fragile when it is wet.

▼ *Use a wash to create the effect of rain by loading your hake brush with darker tone on one side and lighter on the other. Make long streaks with the full width of the brush, tapering it off the paper, then blend the streaks lightly with a clean hake brush. Blend the solid areas of colour as normal.*

FLOWERS AND PLANTS

The Chinese talk of the 'four friends' – plum or jade blossom, bamboo, orchid and chrysanthemum – and it is with these that the student starts to learn to paint.

PLUM BLOSSOM

The tree known to Chinese brush painters as plum or jade is, in fact, the Japanese apricot. The symbol of winter, its blossom and branches are very like those of the almond: five-petalled flowers which come out well in advance of the leaves (luckily for would-be painters, as leaves are more difficult to do than flowers!) and upward-sweeping branches.

THE BRANCH

For the plum blossom branch, use a large 'orchid and bamboo' brush. The main stem should be completed in one continuous movement with a single loading of the brush. To do this exercise, fully charge your brush with a mixture of sky blue, sprout white and autumn brown.

THE FLOWERS

To build up a flower, load a 'plum blossom' brush with water – remembering to drain the excess off with the side of the palette – and pick up thick, neat britch red with just the very tip.

Roll the brush onto the paper to form the different petal shapes, making sure that the heel is pressed down. This will create a damp area for the colour to bleed into. I worked in the direction of the arrows in the example below. However, if you feel more comfortable doing so, it is perfectly all right to roll the brush the other way.

▶ *For the branch, work across the bristles, reversing the stroke very slightly to form the joints. Think about the shape of the branch as you work and take care to make the sections of branch look vigorous and sturdy by working quickly and decisively. Gradually reduce the amount of brush head in contact with the paper so that the branch becomes thinner towards the end. Without refilling the brush, add the side branches, tapering some of their tips. Lastly, dab neat black onto the branch and add some more splodges in opaque Chinese green, 'breaking' the still wet colour.*

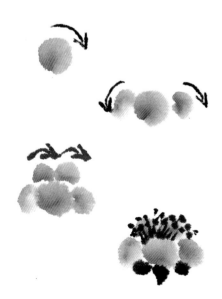

◀ *Do the nearer petals first and don't reload the brush mid-flower. Blossom petals tend to overlap, so keep the petals close together – each stroke will show up individually even if they run together slightly. Draw stamens in thick black ink with the brush tip (always from the flower's centre) using short tapered strokes. Make the pollen with random stabs of the brush tip and form the sepals by laying the brush down sideways and pressing, tapering the brush off the paper for the central sepal. As the stamens, pollen and sepals are added before the petals have dried, the slight blurring helps them to blend into the flower.*

I have also shown flowers seen from different angles (right). You can achieve a two-tone effect with pink, rather than red, flowers by loading the brush with thin Chinese white, instead of with water, before tipping it with neat red.

THE BEE
Chinese flower paintings are often enhanced by the addition of an insect. See my example of how to paint the bee (below).

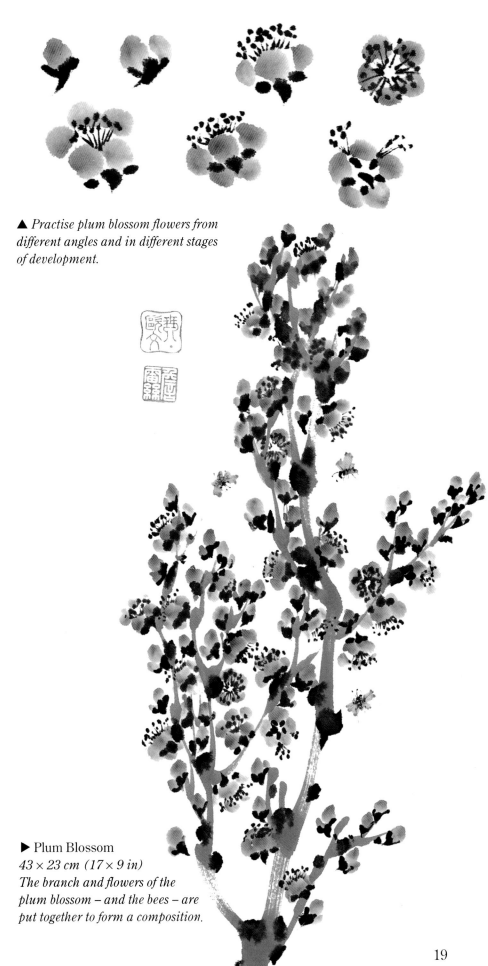

▲ *Practise plum blossom flowers from different angles and in different stages of development.*

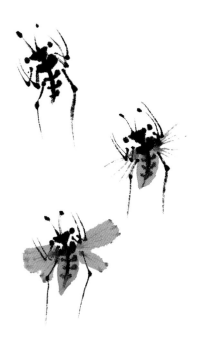

▲ *Draw the head, thorax and stripes of the bee with the brush tip, using thick black ink. Add the antennae and the legs with firm, light strokes, tapering the ends of the legs. Mark the wings in with a tapered, feathered stroke in light grey ink. Next, fill the brush with yellow and tip it with burnt sienna. Press it down lightly onto the paper to form the shape of the body, keeping the tip of the brush towards the head. Then fill the brush with watery white and press it down over the wings with the tip towards the thorax. Lastly, add a few light markings to emphasize the tips of the wings.*

▶ Plum Blossom
43 × 23 cm (17 × 9 in)
The branch and flowers of the plum blossom – and the bees – are put together to form a composition.

BAMBOO

The second of the 'four friends', bamboo, is known as a gentleman. The Chinese regard it as virtuous, hardy, upright and humble. It is also consistent as it grows throughout the year.

For many years I have painted bamboo according to the time-honoured method I was taught by my brilliant teacher, Professor Chen Bing Sun, when I was living in the Far East. However, I recently watched Qu Lei Lei, a Chinese painter living in Britain, depict bamboo by a slightly different and, I believe, more expressive method, and I have adapted my own technique accordingly. I now make much more use of reversed direction strokes.

THE STEM

In my example (right) I created the main shape of the stem by doing a series of strokes similar to the blunt 'bone' stroke shown on page 13. However, instead of tipping the brush with darker tone, I carefully picked up thick ink from the stone with just the side of the brush head.

In strokes like this the ink will miss the paper in places. This effect is known as 'flying white' and helps to give texture to a shape. Use a large brush loaded with just enough ink and never reload your brush during a single stem. Provided the brush is not too wet, this hit-and-miss effect should happen naturally.

THE LEAVES

Bamboo leaves are done with a large 'orchid and bamboo' brush. It is worth remembering that some leaves will appear narrower because they are seen sideways on, and immature leaves will tend

▶ *To paint the stem, work along the bristles the way the plant grows, tapering the top segment off the paper. Side stems always grow from joints and these too should be formed with quick 'bone' strokes, this time using just the tip of the brush. The last section should be tapered. Reinforce the joints on the stem with thick black ink, roughly following the divisions between segments. Carry the line slightly outside the stem and reinforce one side by flicking the stroke slightly at the end as shown by the arrow.*

▼ *To do each leaf in a typical cluster, fill the brush with liquid black ink and taper the tip onto the paper, then immediately reverse it. Without slackening speed, lower the brush gradually onto the paper and then smoothly taper it off again. It is important to caress the paper rather than to snatch at the stroke.*

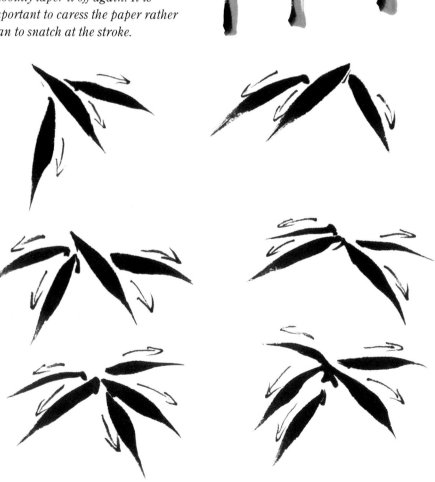

to be smaller. Do not worry if some of your leaves split slightly. This is not considered wrong as leaves themselves frequently fray. Overlapping the clusters will create the impression of some leaves being behind others while allowing individual leaves to show. Light leaves should be added after the dark ones. This causes the darker leaves to blur just a little in places. If you put dark leaves on top of light ones everything would run into an amorphous blob.

Once the leaves are finished, it is usually necessary to add a few extra side stems to join stray leaf clusters to the rest of the plant (right).

It is very important to complete a bamboo painting 'in one breath'. Adding wet to wet causes some blurring but enhances the vigour and liveliness of the composition rather than being a fault. The Chinese consider it a compliment to describe a painting as *chuo* or awkward. They do not admire paintings that are *chiao* – dextrous and clever but lacking in feeling.

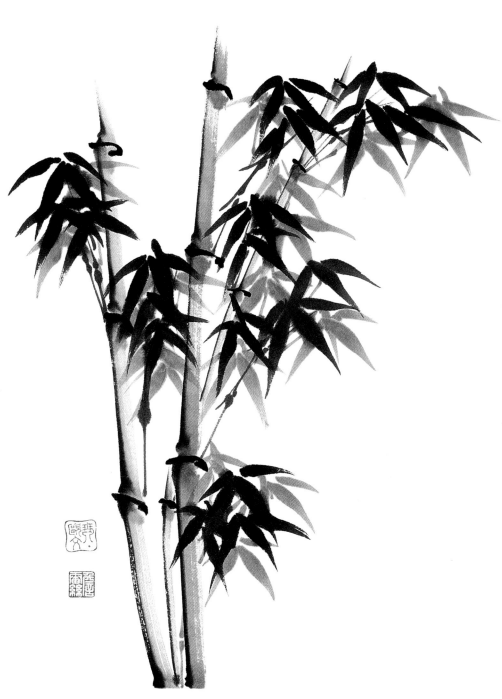

▲ Bamboo
48 × 42 cm (19 × 16½ in)
The narrow main stem which joins the two upright ones was done with the same large brush as the wider ones but using less of the head.

ORCHID

The third of the 'four friends', the wild orchid, is essentially feminine, symbolizing serenity in obscurity. Its perfume is highly prized, especially as the flower tends to grow deep in the forest.

THE FLOWERS
You can begin with either the flowers or the leaves. I normally start with the flowers, using a 'plum blossom' brush. For this exercise, fully load your brush with squab red, toned down with indigo, and tipped in neat peony purple.

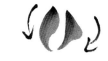
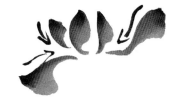
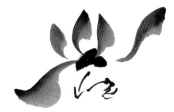

◀ *To build up the flower, begin with the two central petals. Bring the brush onto the paper at an angle, in the direction of the arrow, and gradually turn it to taper it off along the bristles. Add the two outer petals in the same way but use slightly more of the brush head and elongate the taper. Make the fifth petal smaller than the others. The stamens consist of three quick, pressed-down dabs of the side of the brush tip. Do these in a single movement without lifting the brush completely off the paper in between each dab.*

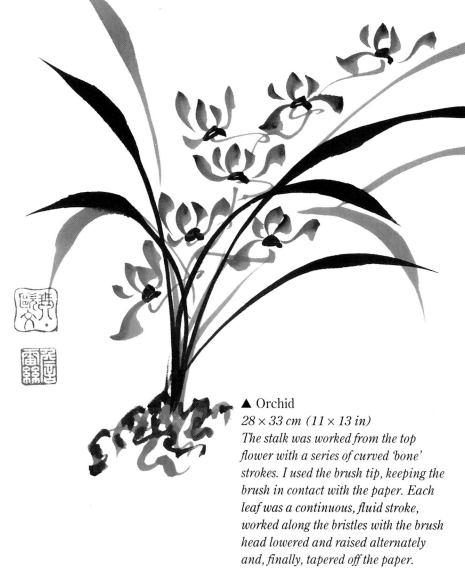

▲ Orchid
28 × 33 cm (11 × 13 in)
The stalk was worked from the top flower with a series of curved 'bone' strokes. I used the brush tip, keeping the brush in contact with the paper. Each leaf was a continuous, fluid stroke, worked along the bristles with the brush head lowered and raised alternately and, finally, tapered off the paper.

THE STALK
Add the stalk to the flowers and not the flowers to the stalk (see left). Join the other flowers to the main stem with similar strokes.

THE LEAVES
Use a small 'orchid and bamboo' brush. Don't worry if some of your leaf ends split slightly as the brush starts to run out of ink. To avoid excessive blurring, do the darker leaves before the lighter ones. It is considered very important to have leaves crossing one another, creating spaces.

THE ROOTS
The roots are just squiggles – do the light ones first.

CHRYSANTHEMUM

The last of the 'four friends', the chrysanthemum, is highly valued in China because it is long-lasting and defies the frost by blooming in autumn.

THE FLOWERS
When painting any flower with a lot of petals, it is important to know where the centre of the flower is and to make sure that all the petals grow in the right direction. With flowers viewed from the side, the sepals should be put in first to centre the flower.

THE STEM
The stem of the chrysanthemum is a fatter, slightly straighter version of the orchid stem.

THE LEAVES
As for the orchid, use a large 'orchid and bamboo' brush to paint the leaves. I have numbered the strokes in my example to show the order in which they should be done.

Remember to use the whole of the brush head when painting any sort of leaf. You should make sure that each stroke is contributing to the shape and not just filling in. Remember, too, that leaves can be seen from different angles and that you cannot always see the whole leaf.

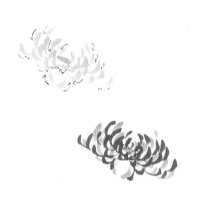

▲ *For the flower, start with the centre, laying the brush down sideways and pressing lightly. Use a 'plum blossom' brush loaded with straw yellow, and paint the lighter petals with curved strokes, following the direction of the arrows and tapering the brush off the paper. Begin at the centre of the flower and work outwards. While the yellow is still wet, fill the brush with vermillion, darkened with bloody red, and superimpose the darker petals.*

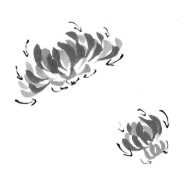

▲ *For sideview flowers, form each sepal by pressing the brush tip onto the paper and pulling it down very slightly.*

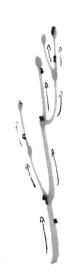

▲ *For the stem, use more of the brush head than you did for the orchid, and add a few dabs of dark ink as you did for plum blossom.*

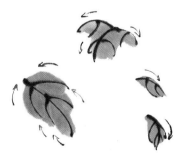

▲ *Work each section of the first leaf across the bristles. Make each section of the next leaf by pressing the brush down firmly, with its tip towards the centre vein. For the smaller leaves, taper the brush down, then press and turn it before tapering it off again. Add the veins in thick black ink.*

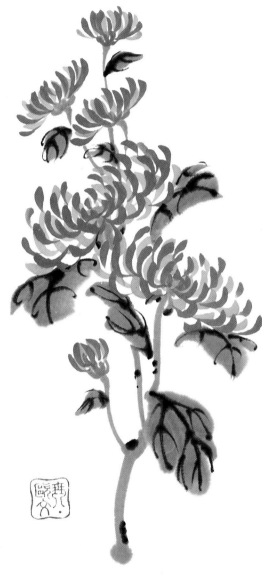

▲ Chrysanthemum
33 × 17 cm (13 × 7 in)
I began this painting by doing all the flowers. Then I added the stem and leaves.

ROSE

The Chinese believe that it is unlucky to have a wild rose growing in the garden because its thorns may cause dissension in the family. I do not know if a similar fear applies to the cultivated variety shown here but Chinese brush paintings of roses are certainly not particularly common, although they do exist.

▼ *To paint the flower, start with the centre petals and work outwards. For each petal, taper the brush onto the paper along the bristles and then turn it before tapering it off again. Remember that rose petals fold round each other in a very characteristic manner. For all the inner petals, turn the brush so that its tip is towards the centre of the flower. However, for the outermost petals, where they have begun to fold out, turn the brush so that the tip is towards the outer edge of the flower. You may reinforce the shapes of a few petals, while they are still wet, by bleeding in a little more red with the tip of the brush.*

THE FLOWERS

Always begin a painting of any large petalled flower with the actual flowers. My example (below) shows how to build up a flower. To do this exercise, load a large brush with Chinese white and fill just the tip with thick, strong bright red.

For the half-opened flowers, load the brush as before and lay it on the paper so that the tip forms the top of each petal. Then turn it very slightly, pressing down with the heel of the brush.

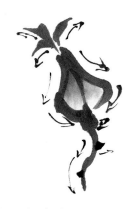

▲ *Draw in the buds with the tip of the brush, using a mixture of bloody red and autumn brown. Then refill the brush as for the petals and press it, tip upwards, into each gap.*

THE STEM

Do the stem of the rose with an unbroken sequence of 'bone' strokes, adding some splodges of light green in places. The thorns should be done in thick ink.

THE LEAVES

The leaves of roses grow in sets of five. For this exercise, your leaf colour should be a mixture of indigo, burnt sienna and straw yellow, tipped with bloody red.

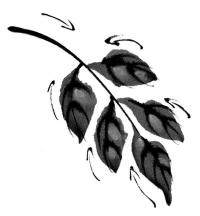

▲ *Use black ink to put in the centre stem for each set of five leaves. Next, fill your brush with leaf colour and paint each leaf in just one stroke – taper the brush onto the paper, press it down briefly, and then taper it off immediately, turning it slightly. Then paint the veins in thick black and add some dabs of light green while the leaves are still wet.*

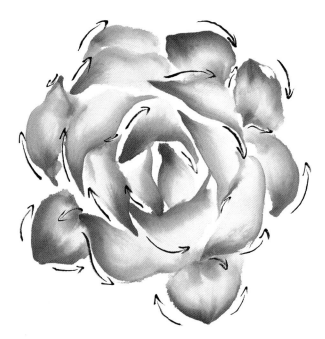

▶ Rose
68 × 42 cm (27 × 16½ in)
The main wash colour here was a mixture of sky blue and prussian blue, toned down with autumn brown. I concentrated the darkest tones behind the flowers and leaves, blending watery straw yellow behind the open flowers.

PEONY

The peony most commonly depicted in Chinese brush painting is the tree peony. Popular with gardeners, the tree peony represents spring and is known as the 'king of flowers' or the 'flower of riches and honour'. It is also a symbol of love and affection and is thought to bring good luck, provided it is healthy – a dying peony is an omen of disaster for the family owning it.

THE FLOWERS

When making the initial flower shape, keep the heel of the brush outwards. Check that there is water in the heel of the brush so that when it is pressed down onto the paper the colour bleeds into the damped area left by the heel, creating a gradual fade-out. If you fill the whole brush with colour, and leave no room for any water, your pink area will have a distinct edge. If you use a second stroke, make sure it overlaps the first.

The half-opened flower in my completed painting was done with the same method as the flower, although I put in the sepals first, loading the brush as for the stalk but this time tipping it with red rather than stroking the sides with it.

THE STEM

The woodier part of the stem in my completed painting was done using a mixture of autumn brown and light green. In order to keep the brush moving freely you should work down from the stalks rather than up to meet them. The black emphasis and light green were added immediately, together with the vermillion tendrils.

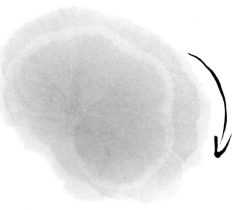

◀ *For each flower, fill a large brush with water and then charge the top two-thirds of the head with dilute bright red. Press the brush firmly onto the paper, with its tip towards the centre of the flower, and roll it slowly all the way round, keeping the tip in the same place. If you do not have a very large brush you may need to add a second ring of colour around the first.*

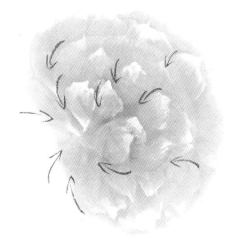

◀ *Put in the petals with a large 'orchid and bamboo' brush, while the pink is still wet. Fill the brush with watery gouache white and tip it with thick white, straight from the pot. Place the brush so that the tip forms the outer edges of the petals and work from the centre outwards, leaving a space for the seed pod. Working with white is comparatively easy because it is the one colour that you can touch up!*

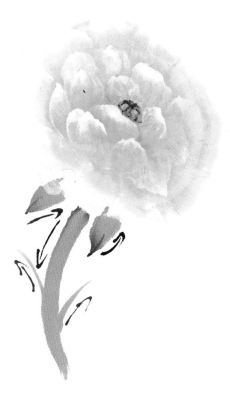

◀ *Wait until the flower is dry before adding the seed pod. Use a mixture of light green, indigo and burnt sienna. The pod is made up of segments rather like a melon – emphasize the divisions with darker tone and highlight the segments with light green. Add the stamens and pollen after the seed pod. For the stalk, fill the brush with a mixture of straw yellow, indigo and burnt sienna and just touch the sides with neat red. Start at the flower and work downwards along the bristles, adding side stems for the leaves with the tip of the brush.*

THE LEAVES

Paint the leaves with a large brush filled with a mixture of indigo, autumn brown and light green. Adding the light green helps to limit colour bleeding – this can cause problems with leaves as they have to be done fairly slowly with the brush pressed down. The opaque mineral colour thickens the mixture and it also contains a lot of glue. If colour does run, I wash over it with clean water to avoid a clear edge forming.

▲ *Begin each leaf with the central section, laying the brush on the paper with its tip to the stalk. Then pull the brush, turning it and then tapering it off the paper at an angle. Do the side sections in the same way, and add the veins in thick black and some splodges of light green for lichen. You can improve a great deal on an unpromising leaf shape with convincing veins and lichen!*

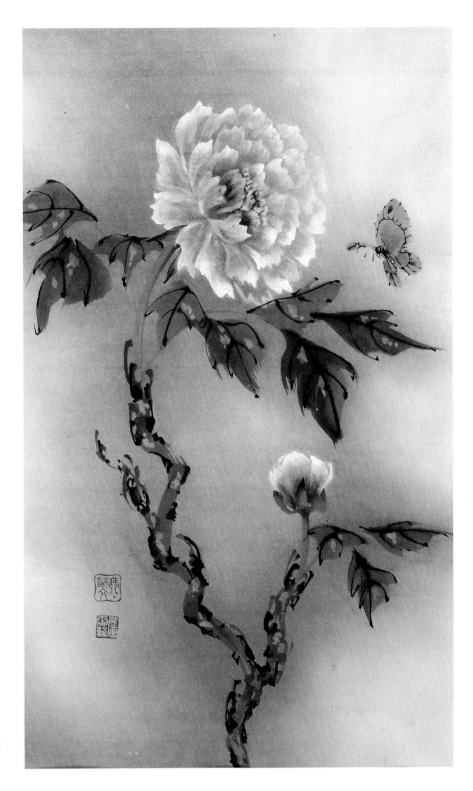

▲ Peony
63 × 38 cm (25 × 15 in)
For instructions on how to do butterflies, such as the one here, turn to the sunflower on the next page.

I cannot find any reference to a symbolic meaning for sunflowers in Chinese culture and they only seem to feature in the repertoire of comparatively few and recent painters, notably followers of the Lingnam tradition.

Sunflowers are fun to paint and 'controlled untidiness' seems to be a good rule for producing effective and striking sunflower pictures. I always use a large coarse brush for sunflowers but you can use any large brush. Try twisting the tip slightly for a more ragged effect.

THE FLOWERS

My example (right) shows the stages of building up a sunflower. For sideview flowers, put in the sepals first using a mixture of straw yellow, autumn brown and indigo, and tip the brush with ink. Do the sepals round the fully opened flowers with the same colours.

▲ *Begin the flowers with the seedhead. Fill your brush completely with straw yellow, then dip it about half-way up into red and tip it with autumn brown. Dab the brush repeatedly onto the paper with the heel towards the centre and the tip pointing outwards. Start in the middle of the seedhead and work outwards, retipping the brush with colour when necessary.*

▲ *Fill your brush with straw yellow and tip it with red. Form each petal with a scooping motion across the brush. You may work out from the seedhead or towards it. Then add a few light flicks of darker colour to the petals.*

▲ *Next, dab a mixture of black, autumn brown and bloody red onto the seedhead and round the outside of it, making sure the brush stays split.*

THE LEAVES

Once all the flowers are in place, add the stalks and the leaves with the same colour that you used for the sepals.

▲ *Form the leaves with one or two strokes. Stroke the brush onto the paper so that its tip forms the base of the leaf. Then move the brush downwards, turning it so that its full width shapes the body of the leaf, and gradually taper it off the paper. For the fatter leaves, do a second, narrower stroke. This time, work upwards from the tip of the leaf. The veins and the outline should be added immediately in rough, untidy strokes.*

THE BUTTERFLY

The sunflower may have no symbolic meaning in Chinese culture, but the butterfly has plenty. It represents summer and is a symbol of joy and conjugal bliss.

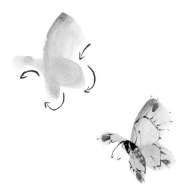

▲ *For the butterfly, use a large 'orchid and bamboo' brush. Begin with the wings, completing all four in a single movement. Lay the brush on the paper, then pull it towards the body across the bristles, curving the wing very slightly. Without turning or lifting the brush, pull it back along its bristles and roll it round to form the second wing. Keep the brush in contact with the paper, pull it across and roll it for the third wing. Lastly, pull it upwards and outwards along its bristles to form the fourth wing, pressing down lightly for the wing tip. Add the body, head, antennae, legs and markings in that order.*

▶ Sunflower
86 × 46 cm (34 × 18 in)
For the butterfly in this completed painting, I did only two of the wings before putting in the body. Then I added the other wings and markings as before.

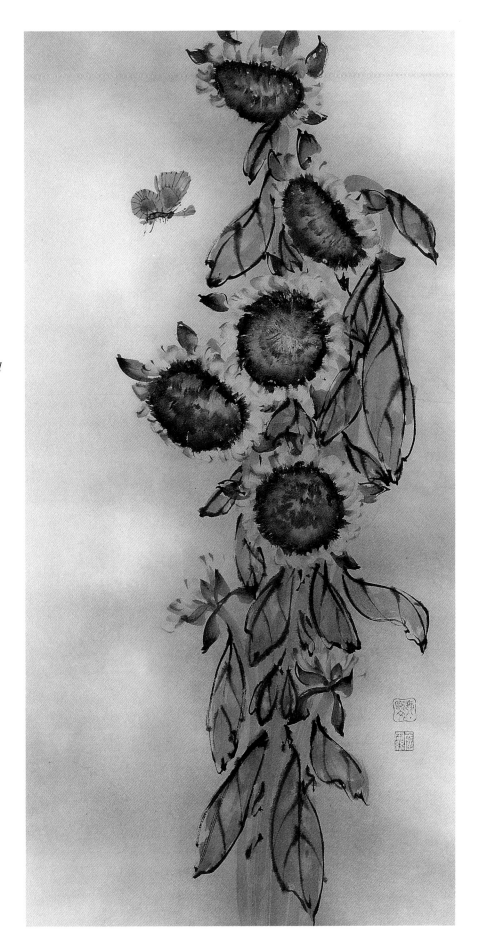

29

DEMONSTRATION: IRIS

You can create interesting effects by doing part of a painting with the paper pre-damped. The irises here and the gladioli on page 64 were done this way and so have 'ghost' flowers which give the picture extra depth. However, for the first stage, I began by working on dry paper.

COLOURS
Squab red; indigo; straw yellow; autumn brown; peony purple.

FIRST STAGE
The flowers were done with a large brush filled with squab red and tipped with indigo. I began each flower with the most central front petal and each petal consisted of one or two strokes. By now you can probably tell how the brush was moved by looking for where the darker colour on the tip has come (refer to page 15 if you aren't sure).

The funnels of the flowers were done by laying the brush on the paper, tip downwards, and pulling it back slightly. I added the dark markings with the brush tip and washed watery yellow over the flower centres.

I did the petals for the buds next, arranging these so that they could all grow from the same stalks as the open flowers.

A mixture of straw yellow, indigo, autumn brown and peony purple was used for the sepals, stalks and leaves. I altered the proportions for some of the leaves to lighten or darken them and tipped the brush with purple for the sepals. The leaves are a fatter, straighter version of orchid leaves. I used a large

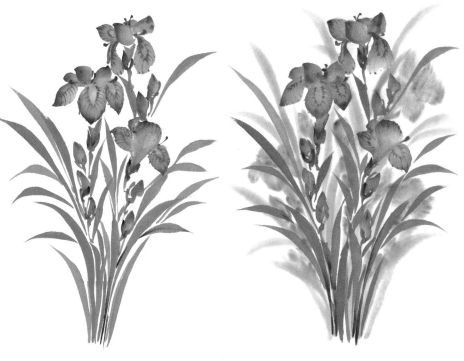

▲ *First stage*　　　▲ *Second stage*

brush and stroked it onto and off the paper in a continuous, fluid movement.

SECOND STAGE
Once the painting had dried, I damped it evenly all over as if for a wash and added the pale flowers and leaves. Notice that these sink behind the more distinct flowers. I kept the colours slightly more dilute than before but not too much because the water on the paper does part of the diluting.

FINISHED STAGE
I then left the painting to dry again before turning it over and redamping it for the wash, which was done on the back. I concentrated the wash behind the plants and tried to use greeny

tones behind the leaves and purply ones behind the flowers. I blended the different colours carefully so that they faded as imperceptibly as possible into each other and into the light areas. Finally, I darkened the wash by adding extra indigo and autumn brown before applying it to the area round the base of the plants.

▶ *Finished stage*, Iris
71 × 48 cm (28 × 16 in)

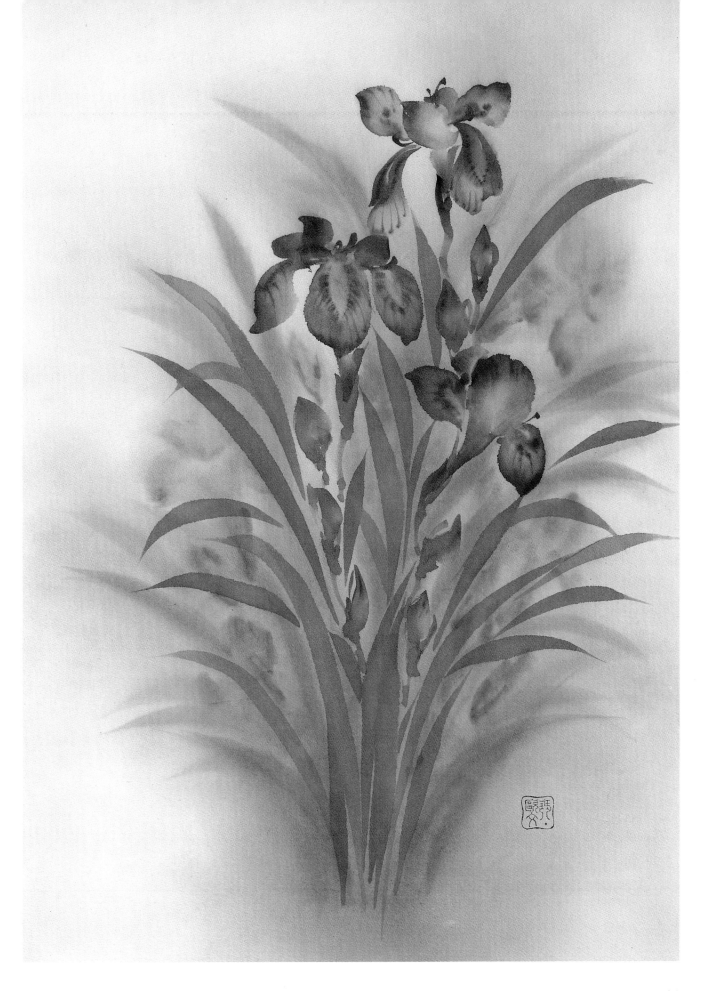

BIRDS

The most important part of painting birds is observation. To be able to paint birds in a way which successfully conveys movement and life, you must watch them and learn what they look like when they are flying, landing, perching and eating.

Remember that birds have chests rather than bellies – it is very easy to make them look egg-bound! Keep your colour fairly dry and strong (don't have it too watery) and use thick, very black ink for wings and markings.

SMALL BIRDS

For the bird in the exercise (right) fill a small 'orchid and bamboo' brush with colour. I lightened my colour with gouache to give it extra body.

The bird at the top of page 33 can be done by exactly the same method, except that the back should be painted first.

▲ *Tip your brush in dark tone and press it firmly onto the paper, then move the heel gently round to form the base of the chest. Next, splay the brush tip and feather the edges of the chest.*

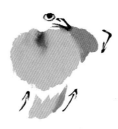

▲ *Still with the brush splayed out, press it lightly twice onto the paper for the tail, pulling it back towards the chest. Put in the shoulder with a sideways stroke and the back of the tail with a simple along-the-bristles stroke. Draw in the eye and the beak, keeping them close to the chest.*

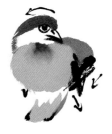

▲ *Fill a 'plum blossom' brush with thick colour and make the top of the head by laying the brush down twice with its tip towards the beak. Curve it gently downwards and taper it off the paper. If you wish, add a little feathering to the back of the head.*

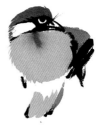

▲ *A small coarse brush is ideal for the wings and to add the feathered markings to the tail and face.*

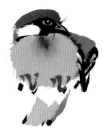

▲ *Put colour round the eye and onto the beak, and draw in the feet. Use gouache paint for the white areas and for the eye highlight.*

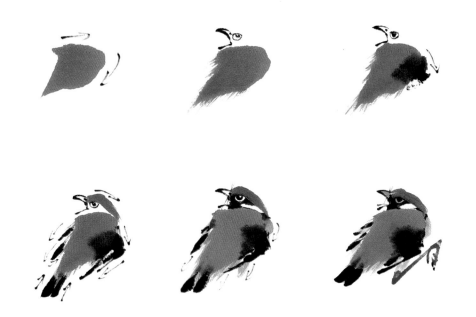

◀ *To paint this bird, fill your brush with colour and lay it, point upwards, on the paper before pulling it to the right with the bristles at an angle of 45 degrees. Then pull the brush backwards, across its bristles, towards the tail, tapering it off the paper. Add the feathered markings. The main shape of the nearer wing should be established with a single stroke, pulling the brush, across the bristles, away from the body. When doing a bird from this angle you should leave the chest area until you have done the head and wings. Finally, don't forget that a bird with an open beak always needs a tongue!*

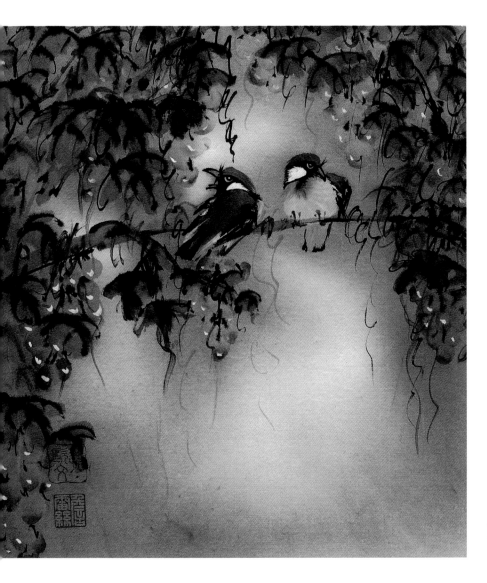

◀ Birds with Fruit
30 × 32 cm (12 × 12½ in)
Once I had done both the birds in this painting, I put in a branch for them to sit on, then added more branches for the fruit.

33

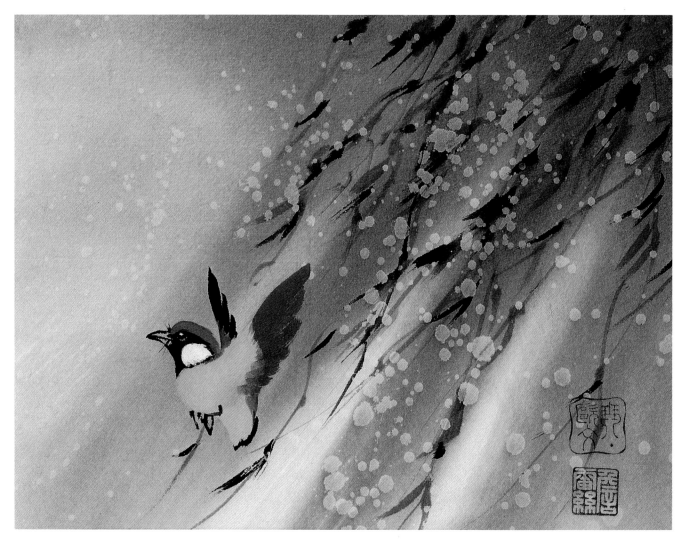

FLYING BIRD

My painting above shows a flying bird. The chest was begun in the same way as the first bird on page 32, but the brush was pulled across and tapered off the paper to form the wing.

I created the underside of the tail by pressing the brush onto the paper with the tip towards the tail, and the wing tips were done from the outside in. (If you try to take them out from the body they usually end up too long.) I added the light blue colour on top of darker tone because I think it looks too insubstantial if used straight onto the paper.

I made the willow look wintery by putting on very few leaves and by angling the fronds to suggest wind.

KINGFISHERS

This painting also contains willow, which was built up in the same way as the iris on page 30.

I did the main branches and some fronds and leaves while the paper was still dry, then damped the paper and added a second layer of fronds and leaves. Once I had done the wash, I painted in some opaque, light green leaves.

The moon was painted in white on the back of the picture. The wash was then added to the front.

▲ Flying Bird in Snow
28 × 20 cm (11 × 8 in)
The snowy effect was created by flicking full-cream milk onto the paper before doing the wash. I covered the bird with a piece of card to protect it from the milk and allowed the milk to dry before damping the paper for the wash. The greasiness in the milk acts as a resist.

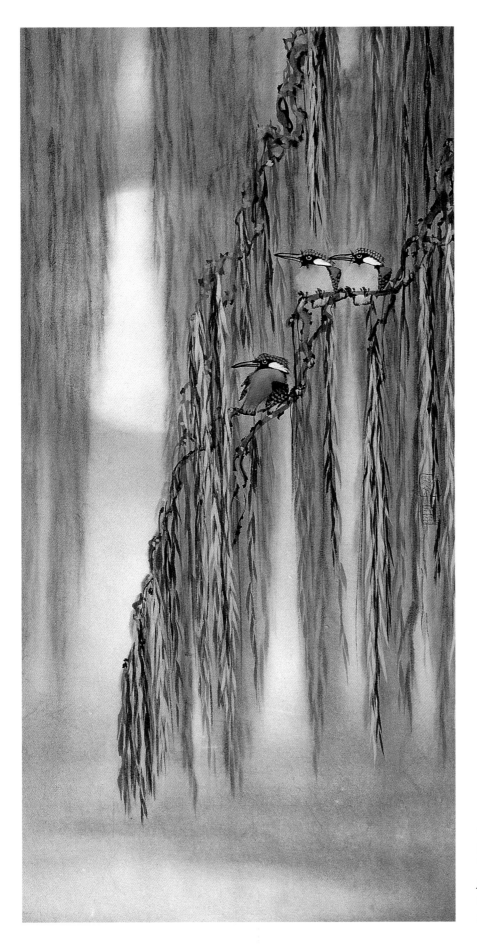

◀ Kingfishers in the Moonlight
90 × 48 cm (35½ × 19 in)
The kingfisher is a symbol of beauty
for the Chinese and its bright
colouring has been much copied in art
and decoration.

35

COCK AND HEN

The chicken is the tenth creature in the series of twelve which represent the terrestrial branches. These branches mark the twelve places where the sun and the moon come into conjunction, and the Chinese have a cycle of twelve years, each named after one of the twelve creatures. People are thought to inherit the characteristics of the animal of the year of their birth.

The cock is an embodiment of *yang*. He is supposed to be able to change himself into human shape in order to bring either good or evil. His comb is like a crown, which is a sign of a literary spirit, while his spurs show a martial side to his nature. He is brave, kind and faithful.

The cock's crow is sometimes seen as a sign or portent, while the clucking of the hen is a symbol of female power within the household.

THE COCK

I added the wattle and the comb as shown in the exercise on the right, and lightly drew in the neck, back and wings with grey. Then I changed to a large brush filled with grey and tipped with black, and created the chest and stomach by laying the brush onto the paper and pressing hard, several times. Most of the black in the tip had been used up by the time I reached the stomach. Then I feathered the back of the tops of the legs.

The tail was created by sweeping a large coarse brush out from the body along the bristles and turning it so that the brush head came off the paper at an angle. This made the feathers look ragged at the ends where the strokes were tapered off the

paper. Next, I added colour to the eye and the beak and finally put a white wash over the neck, back and wings.

THE HEN

The hen was done in exactly the same way, except that I was careful to keep her comb and wattle small. Her tail feathers were worked across the bristles of the brush, this time in towards the body.

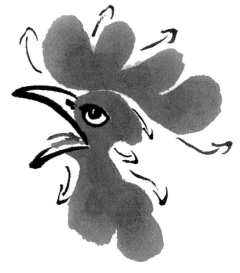

▲ *Fill a small 'orchid and bamboo' brush with britch red and lay it carefully onto the paper above the eye, with its tip towards the beak. Press down lightly. Repeat this stroke below the eye and do the same thing twice more to form the wattle. For the comb, place the brush above the beak, with the tip towards the top of the head, and press down. Next, lifting the heel but keeping the tip on the paper, move the brush along and press down again three more times. Finally, put in the tongue.*

▲ *Use a large brush to paint the tail feathers.*

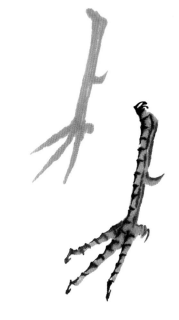

▲ *Establish the shape of the leg in grey ink and then pick out the detail in black ink.*

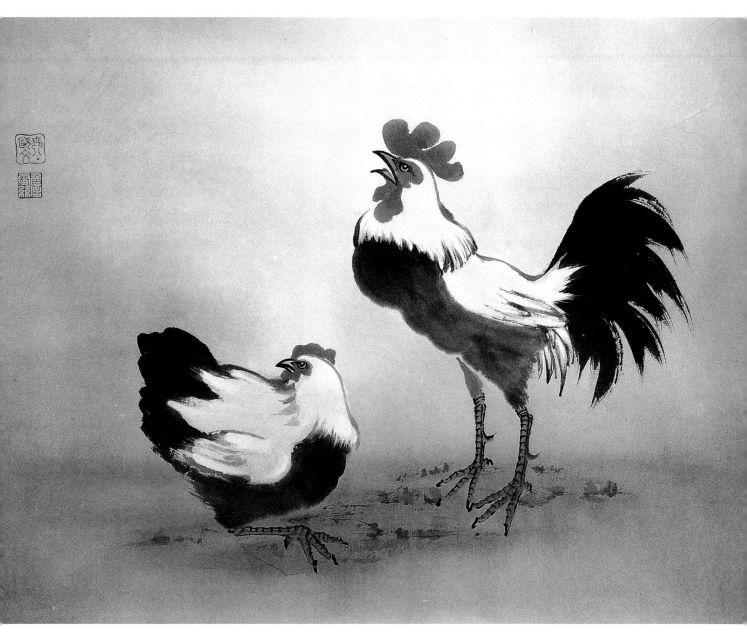

▲ Cock and Hen
45 × 63 cm (18 × 25 in)
When painting large birds like this, I think it is usually easier to begin by placing the eye and the beak, drawing them in with thick black ink.

DUCK

The duck is a symbol of happiness in Chinese mythology – as well as being much in demand as food!

THE DRAKE
Because I thought he would be the more difficult to do, I began the painting on the opposite page with the flying duck. I drew in the eye and the beak and then used a large 'orchid and bamboo' brush filled with thick black ink to do the head and neck. Just three strokes were used: one for the top of the head; one for the cheek; and a sideways stroke across the bristles for the neck, which was feathered slightly at the base.

The wings were painted next (see detail, right). Before putting in the back (see detail from the female duck, opposite) I outlined the chest and stomach and put in the legs, establishing their shape in colour, then adding black markings and light highlights.

I put in the second wing and the tail and then blended colour onto the chest and stomach. This was done by covering the area with white and then carefully blending the darker tones on top. I used a clean brush to complete the blending and added some feathered strokes to the top of the legs.

A little Chinese light blue was blended onto the head and neck. Chinese light blue is opaque – if you do not have any, you can use Japanese sky blue mixed with gouache white.

THE FEMALE DUCK
I was very pleased with the male bird and nervous about spoiling the picture by making a mistake with the female. I therefore placed her far enough away so

that I could cut her out of the picture if necessary and have just a single duck!

The method was essentially the same as for the male but this time I lightly outlined the head, neck and chest before putting on the feathers and used a coarse brush for the wings and tail feathers.

▶ *The shape of the wing was established by working a sweeping stroke out from the body across the bristles of the brush, creating the front edge. The brush was loaded with light colour and tipped in ink. The flight feathers were worked in towards the body, still using the brush sideways. The rest of the wing was filled in by repeatedly dabbing a coarse brush, loaded with light colour and tipped with dark, onto the paper to suggest two rows of feathers.*

▲ *For the dappled effect on the backs of both ducks, a small coarse brush was loaded with light colour and tipped with dark colour. The brush was repeatedly pressed lightly onto the paper and lifted off cleanly. A few dabs of gouache white were then added to enhance the feathery effect.*

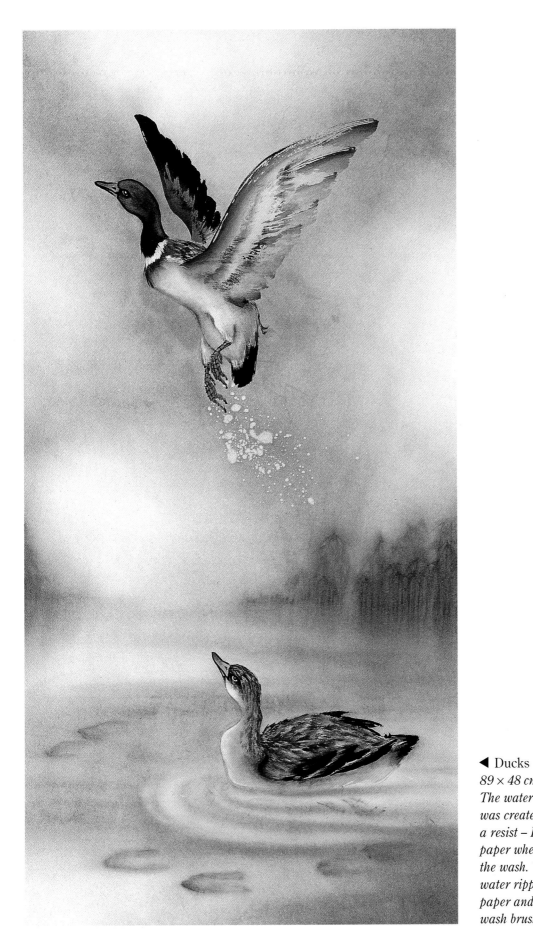

◀ Ducks
89 × 48 cm (35½ × 19 in)
The water coming off the duck's feet was created by using single cream as a resist – I simply dripped it onto the paper where I wanted it before doing the wash. The reeds, lily pads and water ripples were all drawn onto wet paper and blended in with a clean wash brush at the wash stage.

FISH AND AQUATIC CREATURES

The fish in Chinese culture represents wealth and plenty and is a sign of regeneration. It symbolizes harmony and marital happiness, while a pair of fish in a painting signifies the joy of sexual union. Fish are thought to be able to avert evil. They also represent freedom because they can move easily in any direction.

The main thing to remember when painting fish is that they do not have necks! If you find that your colour runs outside the fish, do not worry about this too much – simply wash over the colour run with clean water and blend the extra colour into your overall wash.

▼ *Begin by painting in the eye in black. Then use a small brush to draw in the shape of the fish, leaving a gap for the dorsal fin.*

◄ *Mark in the scales with rows of watery dabs, using grey ink for the back and side and thin white for the belly. Use a small 'orchid and bamboo' brush for the tail, creating its shape with two strokes worked across the bristles and tapered onto and off the paper. Gently touch up the area where the tail joins the body to make it look rounded. Then form the dorsal fin with several tapered strokes, working away from the body with the brush at right angles to it. Work the smaller fins out from the body along the bristles, tapering the brush onto and off the paper.*

◄ *Put colour onto the body, starting with the darker tones. It is important to use a brush large enough to be able to keep water in the heel, so that the colour bleeds gently into the lighter areas when you press the brush onto the paper. Run a thin white wash over the whole fish and blend thicker white onto the belly, head and gills. Put blue round the eyes. Lastly, add the markings to the tail and fins, and highlight the eye.*

▶ Fish
56 × 40 cm (22 × 16 in)
I did the wash for this painting from the front, streaking some of the colour over the fish so that they looked as if they were under water. The lily pads and weeds were painted on while the paper was still wet.

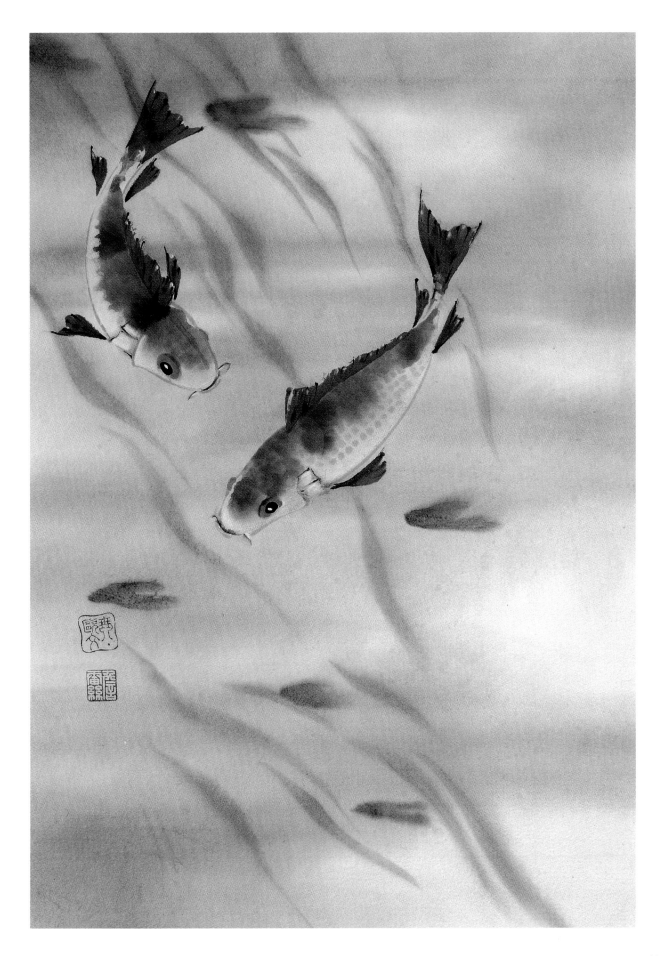

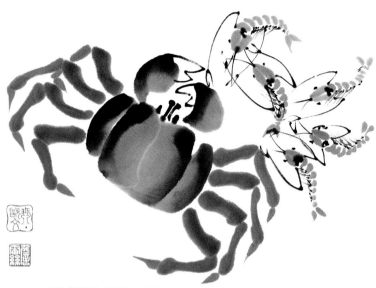

PRAWN AND CRAB

I have been unable to find a symbolic meaning for the prawn or the crab. I'm surprised, as prawns, in particular, feature a great deal in Chinese cooking, and most valued foodstuffs are heavily imbued with meaning.

Prawns and crabs are relatively easy to paint and must always be done 'in one breath'. At the risk of making it look like an advertisement for seafood, I have put prawns and crabs together for my picture above!

TURTLE

The turtle is the king of the shelled creatures. It is a sacred representation of the universe: its domed shell is the vault of the sky; its belly is the earth; and it swims in the sea. The markings on the upper shell are thought to correspond to the constellations and are *yang*; and those round the base of the shell represent the earth and are *yin*. Turtles symbolize longevity, strength and endurance, and represent winter. They are kept in pools at Buddhist temples and it is considered very meritorious to feed them or to replenish their stocks.

▲ Prawn and Crab
28 × 35 cm (11 × 14 in)
I used a large brush for the crab, and made the centre of the shell with two sideways 'bone' strokes, using the whole brush head and reversing the brush for the second stroke so that the darker tip formed the outer edge. The side sections were worked across the bristles, using less of the brush head. I put in the legs next. Each walking leg consisted of two 'bone' strokes and a third tapered stroke for the foot. Then I added the eyes and the mouth and drew in the pincers in black.

I did the prawns with a small 'orchid and bamboo' brush, making each head with two strokes, tapering the brush tip onto the paper and pressing down the heel. Each back was a series of small curved 'bone' strokes, done across the brush tip. The tails consisted of two strokes. I added the eyes and other markings in thick black, and drew in the legs, tentacles and pincers with the tip of the brush.

▶ Turtle
85 × 48 cm (33½ × 19 in)
I used a large brush to form the shell, working a rough oval shape across the bristles and adding a few light markings where necessary. I marked in the head, then added the legs and the tail. While the ink was still wet, I drew in the black markings on the shell and head, and gave the feet claws.

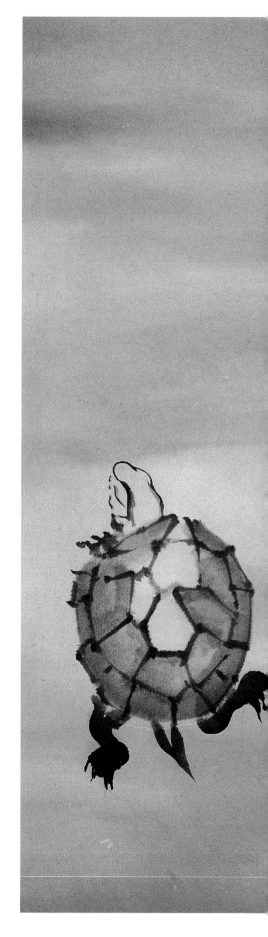

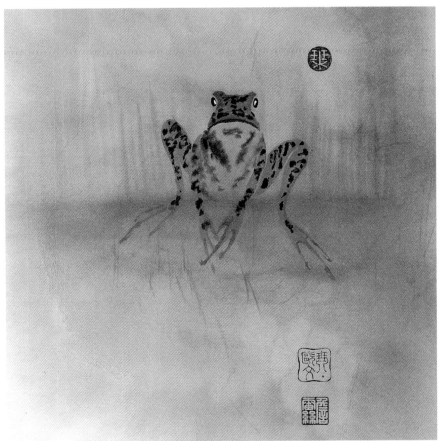

FROG

The Chinese do not seem to distinguish clearly between frogs and toads. Frogspawn was thought to fall from heaven with the dew and the frog is therefore known as the 'heavenly chicken'. Possibly the fact that frogs' legs taste like very tender chicken has something to do with this!

Chinese mythology contains a three-legged toad which lives in the moon and swallows it during eclipses. Frogs and toads represent the unobtainable, while also symbolizing money-making.

Notice how I made the wash patchy – this mirrors the uneven colouring of the frog.

▲ Frog
38 × 31 cm (15 × 12½ in)
After drawing in the frog's mouth, I used a large 'orchid and bamboo' brush, loaded with dirty green and tipped in bloody red, to build up the head: one stroke above the mouth; one for each eye socket; and one for the top of the head. Each front leg was a single, sideways stroke, pulled out for the beginnings of toes at the bottom. I used a single stroke for each hind leg section, pressing the brush onto the paper to shape the thighs and calves. The belly was a lighter dirty green colour and the toes a thin dark red. I painted the eyes in black with a straw yellow surround, dabbed on the black markings and added light green splodges on top of some of these.

ANIMALS

Chinese brush painting materials are ideally suited to depicting furry animals but it is easy to get carried away and overload the brush. Do the stroke slowly, rather than with a sopping wet brush. Colours and ink tones should still be vigorous.

As with birds, it is vital to watch animals if you want to paint them successfully. When one of my students gets an animal wrong, I often discover that they do not have a clear idea of what it really looks like!

RABBIT

The rabbit or hare is the fourth creature in the series representing the twelve terrestrial branches. It is yet another symbol of longevity and it is believed to derive its existence from the moon.

As with most animals, I began by drawing in the rabbit's eye and then filled a large brush with grey ink, tapered its tip onto the paper in front of the eye, and pressed down. I slowly moved the brush towards the back of the head, along the bristles, and then round the eye, across the bristles, and finally pulled it round, along the bristles, to meet the start of the stroke in front of the eye.

The bump for the other eye was put in next and the rest of the face and the nose drawn in.

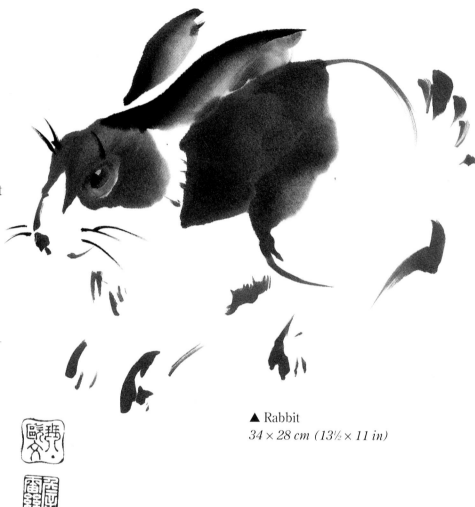

▲ Rabbit
34 × 28 cm (13½ × 11 in)

I refilled the brush, this time tipping it with darker ink, and painted the ears out from the head, tapering the brush onto the paper. As I moved the brush along, I turned it to an angle of about 45 degrees and pressed down with the heel before gently tapering the stroke off the paper.

I did the grey patch on the back by pressing the brush onto the paper and moving it slowly over the area, not lifting it until the patch was completed. A similar stroke formed the curve where the rear leg joins the body.

The rest of the body, the legs and the scut were drawn with rough, free strokes. The eye surround and inside of the ear were done with dilute bloody red, and the whiskers were tapered on with thick black. Finally, I highlighted the eye with white.

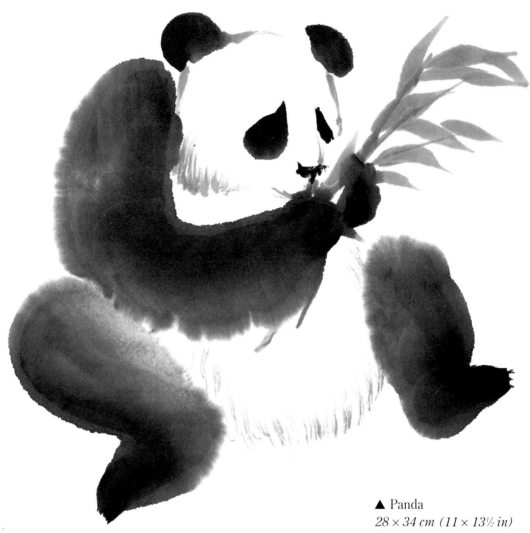

▲ Panda
28 × 34 cm (11 × 13½ in)
*I tapered my brush onto the paper for
the eyes, pressing down before lifting
off, then added the nose and ears. The
rest of the head was done in grey,
using a 'feathered' brush for the cheek.
I used a large brush for the shoulder
and arm and worked down slowly,
pressing the brush on the paper, then
lifting it slightly for the paw. I kept
lighter ink in the brush heel for the leg
below the arm so, when it was pressed
onto the paper, the fur on the inside
was lighter. I worked down from the
knee, across the bristles, turning the
stroke for the foot, then did the belly
with feathered strokes and added the
second leg, another paw and claws.*

PANDA

A charming explanation of how
the panda got its black markings
is that a baby girl was abandoned
in the forest and rescued by a
family of pandas which, at that
time, were all white. They cared
for the little girl and grew to love
her dearly. Sadly, she died and
they decided to hold a grand
funeral ceremony. All the pandas

in China attended and, as a mark
of mourning, covered their arms
and legs in soot. At the funeral,
overcome with grief, they rubbed
their eyes with their paws and
buried their heads in their hands,
clutching their ears.

When painting this panda,
I started, as usual with the eyes,
using a large 'orchid and
bamboo' brush filled with black.
I put in the bamboo last.

While cats are thought to have the power to defeat evil spirits, it is bad luck for a strange cat to enter a household, as the cat is believed to bring poverty with it.

I find cats the most difficult animals to portray convincingly and feel the one here to be the best I have done. Unusually, it is a portrait of a particular animal, although she embodied the qualities I admire most in cats – independence, playfulness, agility, snootiness and laziness. I did not have the cat there when I painted her, but had paid several visits to her owner's house to study her.

Zoë presented a problem because she was very black all over. I experimented by using very dark grey ink so that I could use black to emphasize shape, but the result did not look like Zoë. In the end, I decided to use space, rather than tone, to suggest form and create movement. Because she was a very sleek cat, I worked all the strokes fairly fast, not allowing the ink to 'fur' too much.

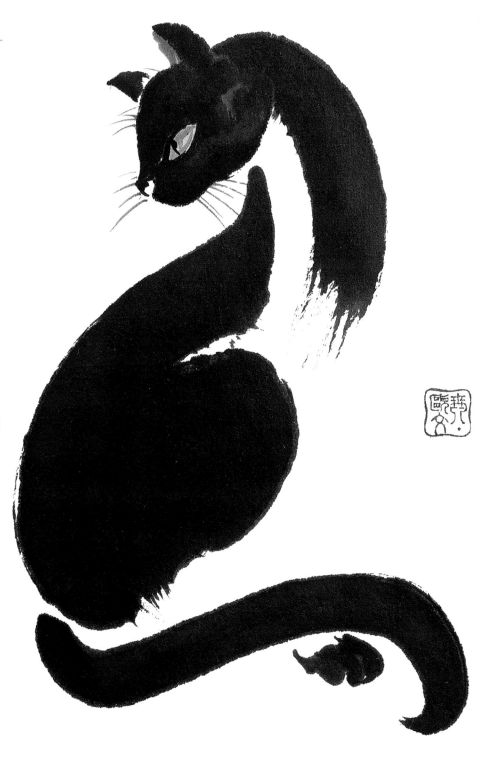

▲ Zoë
43 × 34 cm (17 × 13½ in)
I drew in the eye and the nose, shaped the front of the head with one stroke and the cheek with two strokes, and did the ears. I used a large brush to do a single stroke for the back, starting at the head and sweeping it sideways in a curve. The haunch was done next, then I put the brush at the back of the head and swept it down sideways to form the back of the neck. The tail was another single brush sweep, this time worked along the brush head, starting at the base of the back. I added the paw after doing the tail, then painted the eye yellow and put in the whiskers.

HORSE

The horse, a symbol of speed and perseverence, is the seventh creature in the series representing the twelve terrestrial branches.

Horses have always been an important theme in Chinese painting. They are not an easy subject and people often find it difficult to convey a sense of strength and movement in their pictures of horses.

I have used the example on the right to illustrate the fact that the horse should be begun by using shading to create shape. Because horses are not particularly furry, work your strokes quickly. I used a large brush filled with dilute autumn brown mixed with a tiny bit of bloody red.

▼ *I started with the head, using a single stroke for the cheek and lower mouth, then put in the brow and nose. The neck was formed with two strokes. Starting at the head, I pulled the brush down along the bristles, turning it to finish the stroke across the brush head. The chest and top of the leg were put in, then the belly with a rounded, sideways stroke. Lastly, I added the rump, haunch and the top of the back.*

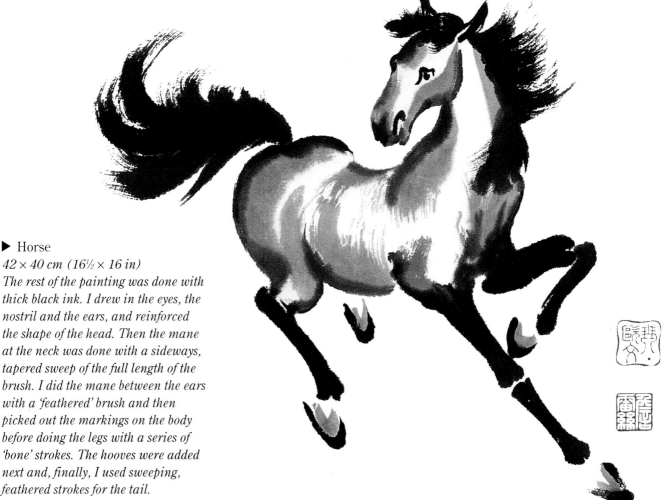

▶ Horse
42 × 40 cm (16½ × 16 in)
The rest of the painting was done with thick black ink. I drew in the eyes, the nostril and the ears, and reinforced the shape of the head. Then the mane at the neck was done with a sideways, tapered sweep of the full length of the brush. I did the mane between the ears with a 'feathered' brush and then picked out the markings on the body before doing the legs with a series of 'bone' strokes. The hooves were added next and, finally, I used sweeping, feathered strokes for the tail.

DEMONSTRATION: TIGER

The tiger is the third creature in the twelve-year cycle. The Chinese regard it as the king of beasts, believing it to be dignified and stern, as well as ferocious and daring.

Unless you are a regular zoo-goer, you may find it difficult to observe the more exotic animals. It is quite all right to consult animal books to check how a tiger's stripes or a leopard's spots are distributed. If you have a copy of my first book, *Chinese Brush Painting*, and remember a picture of a tiger with almost every hair picked out individually, you will be happy to know there is a much quicker way that you can suggest stripey fur!

So far you have painted animals by using the brush to depict shape and fur texture simultaneously. This method does not allow for distinctive markings, such as a tiger's stripes. For these, it is easier to begin with a clear idea of the overall shape before you start adding texture. You will, therefore, find it easier to do a light charcoal sketch first.

COLOURS
Ink; straw yellow; Chinese white; gouache white; vermillion; burnt sienna; autumn brown.

FIRST STAGE
Having done my preliminary charcoal sketch, I drew in the tiger's eye, nose, mouth and ears. The black stripes and markings on the face were done using strokes tapered at both ends with the brush held at an angle –

I used a medium coarse brush for maximum furry effect.

I changed to a large coarse brush for the stripes on the body, going back to the medium brush for the markings on the tail. A lighter ink was used for the stripes on the chest.

A medium brush was used to draw in the face, light markings for the whiskers, and the body. I used mainly light ink, but did

some parts in black, including the claws. The coarse brush was used for a shaggy effect.

SECOND STAGE
When the ink had dried, I damped the paper before adding the ink shading, using a large brush and making sure I kept water in the heel to avoid hard lines. The paper was then left to dry again.

▲ *First stage*

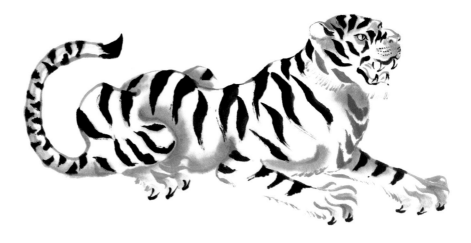

▲ *Second stage*

THIRD STAGE

The paper was redamped before applying colour. I began by putting on a light wash of straw yellow for the coloured areas and thin white for the light parts of the face, belly, chest and feet.

You will see that the colour has run outside the outline. Subsequent layers of colour will do the same thing. You can minimize this slightly by letting the paint dry in between each application of colour. However, this is very time-consuming and I prefer to incorporate any colour run into the wash, as I did for the picture in the finished stage.

FINISHED STAGE

I then built up layers of colour: first vermillion; then burnt sienna; and, lastly, a little autumn brown. Each colour was blended over a smaller area than the one before, so that the tiger's colour gradually changed from dark in the middle of his back to white on his belly. I blended thicker white onto the chest and cheek, and round the eyes and mouth.

Once the paper had dried, I put colour onto the eye and the mouth and added the white whiskers. I also feathered some white onto the inside of the ear, round the face and on the undersides of the legs and feet.

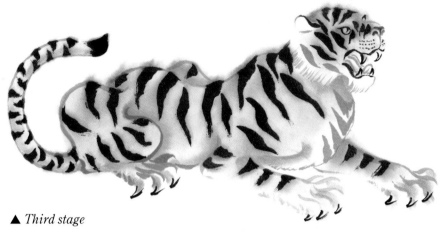

▲ *Third stage*

▼ *Finished stage*, Tiger
45 × 89 cm (18 × 35½ in)

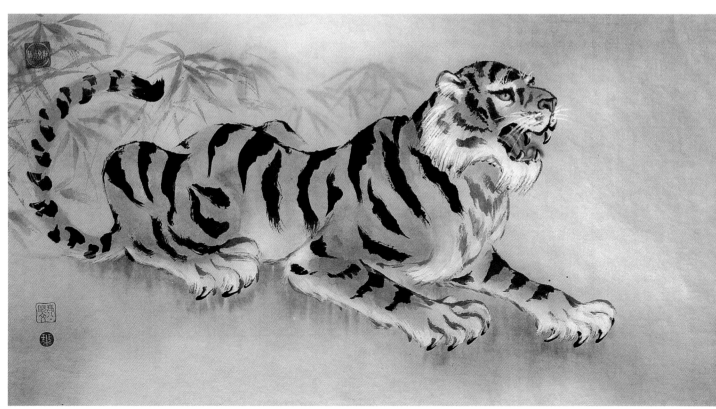

49

PEOPLE

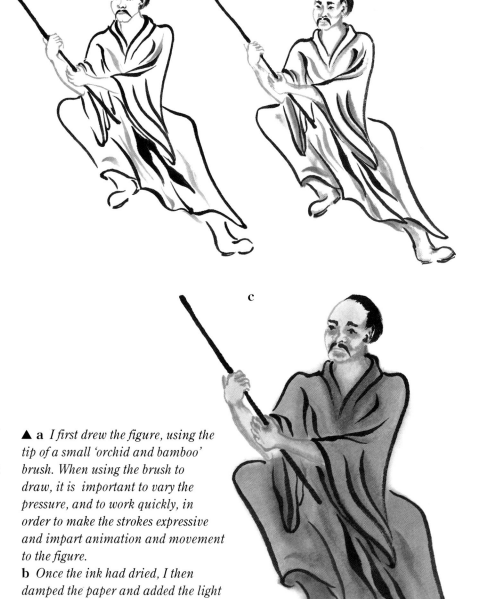

There does not seem to be as strong a tradition of figure painting or drawing in China as there is in the West. Apart from contemporary works, I cannot remember any Chinese nudes, and head and shoulder portraits are also comparatively rare.

Fully clothed figures, however, occur frequently in traditional landscape paintings, often engaged in some kind of intellectual or spiritual pursuit. Whereas buildings are normally seen from above, figures are usually shown from the side. They are often simply drawn, with little or no shading, and are sometimes disproportionately small in relation to surrounding trees and rocks, perhaps because the artist wanted to emphasize man's insignificance in the world.

BODY MOVEMENT

Figures in Chinese paintings are usually doing something and so it is essential to understand how the body works. You cannot successfully impart movement and texture to cloth without understanding the anatomy of the body that it covers.

When depicting figures, you can combine two techniques. Try drawing the head, neck, hands and feet by the method shown on this page, but do the clothing by the second method, shown at the top of page 51; or draw part of the clothing and block in the rest.

▲ **a** *I first drew the figure, using the tip of a small 'orchid and bamboo' brush. When using the brush to draw, it is important to vary the pressure, and to work quickly, in order to make the strokes expressive and impart animation and movement to the figure.*
b *Once the ink had dried, I then damped the paper and added the light ink shading.*
c *I allowed the paper to dry before running dilute colour over the clothing and skin. To avoid a harsh edge, you can wash over any colour that runs outside your figure with clean water.*

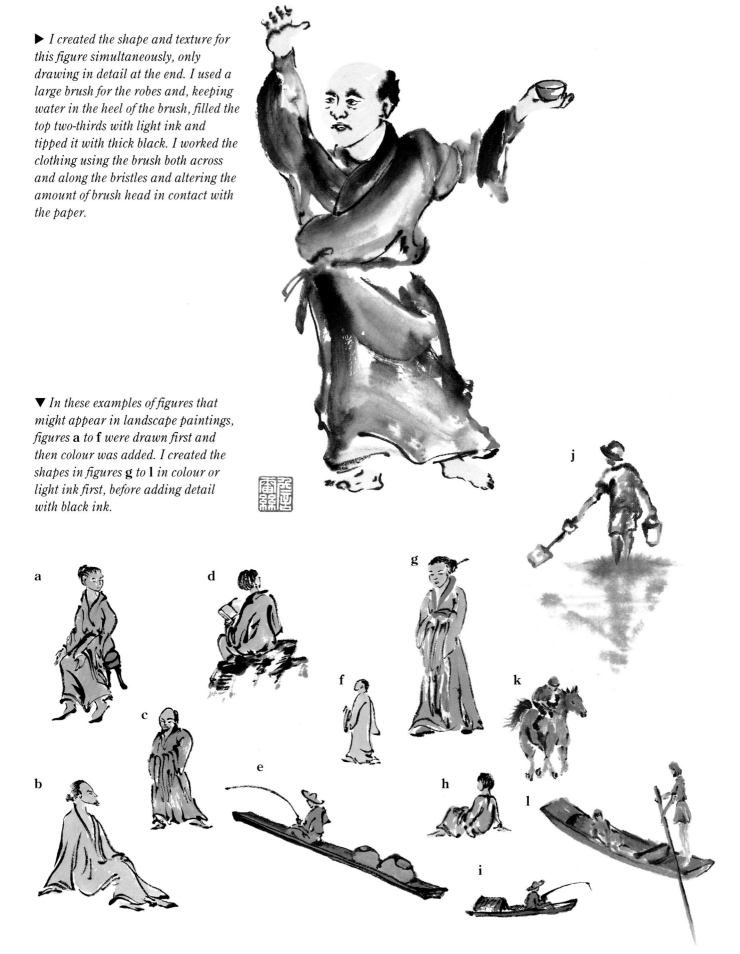

▶ *I created the shape and texture for this figure simultaneously, only drawing in detail at the end. I used a large brush for the robes and, keeping water in the heel of the brush, filled the top two-thirds with light ink and tipped it with thick black. I worked the clothing using the brush both across and along the bristles and altering the amount of brush head in contact with the paper.*

▼ *In these examples of figures that might appear in landscape paintings, figures **a** to **f** were drawn first and then colour was added. I created the shapes in figures **g** to **l** in colour or light ink first, before adding detail with black ink.*

LANDSCAPES

Landscape painting in China traditionally enjoyed a very high status, perhaps because part of a court painter's role was to provide imaginary scenes to help busy civil servants withdraw into contemplation. Until recently, Chinese painters tended to remain detached from painting specific localities, preferring to convey the spirituality and grandeur of nature in general.

Modern Chinese painters do depict real scenery. However, the best ones are still trying to remain true to the Daoist principle of re-creating the spirit or *chi* of a place rather than trying to produce a photograph-like record.

PERSPECTIVE

Although contemporary Chinese painters do use vanishing-point perspective, traditional brush painters treated perspective differently. A scene was depicted as if the middle ground and the distance had been tilted up so that they were higher than the foreground. Landscapes are usually divided into these three elements, which are differentiated by varying tonal values.

Individual elements in a landscape are not always seen from the same viewpoint or lit from a single light source.

Because of the nature of his or her materials, the Chinese brush painter can begin with the foreground and work back into the distance, adding washes last of all. In some traditions sky and water are left unpainted but I find it more effective to suggest these using washes and other wet-paper techniques. Chinese brush painting techniques are also very well suited to depicting Western scenery.

▼ Loch Duich, Scotland
48 × 85 cm (19 × 33½ in)

COMPOSITIONAL ELEMENTS

Scenes are composed of several elements – mountains, sky, a river, trees, buildings and so on. I have singled out a few of these for you to practise individually. You should always try to avoid outlining trees, rocks and hills because this makes them look two-dimensional. Use the brush to create shape and texture at the same time.

In the following examples, the whole process of painting each element is described. However, you should always complete a painting in shades of grey and black before adding colour to any element.

TREES

It is often a good idea to give a painting focus by beginning with a tree in the foreground. Trees, like people, are usually depicted from the side. Two trees which regularly occur in Chinese paintings are the pine (shown right) and the willow, which is shown on the following page.

▶ *a Put in the knot holes, the slit at the trunk's base and the underside of the roots, using a single stroke for each. Establish the shape of the tree in grey, working up the trunk with rough, uneven circles. Put in the side branches and, while the grey is wet, add emphasis with thick black ink.*
b Add the pine needles and the small connecting branches. Put in a few grey needles and then run grey ink down the right-hand side of the trunk, keeping water in the heel of the brush.
c Lastly, run dilute colour over the trunk before damping the paper and putting colour over the needles, blending it outwards with a clean wash brush.

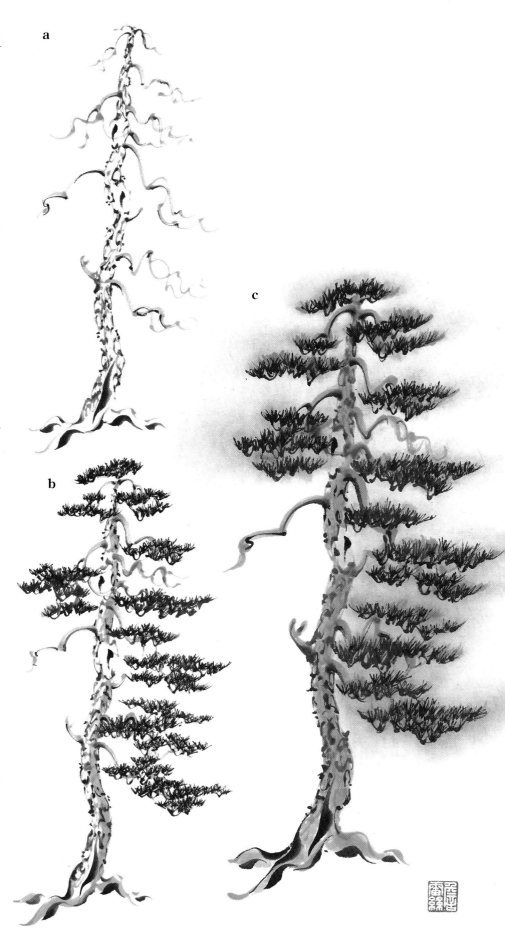

OTHER TREES

Once you have mastered the basic techniques of the pine and willow, different species of trees can easily be suggested by varying the shapes of the trunks and using different ways to suggest foliage.

Often the shape of a trunk can be made with a single stroke. You can either load the brush with more than one tone or you can create the shape first and then use ink to provide detail. Leaves can be outlined or you can do smaller versions of the leaves shown earlier in the book. You can lay the brush on the paper or stab the paper with the tip of the brush. Foliage can also be put in with a small sponge instead of a brush.

TREES IN THE DISTANCE

Distant trees need to be painted in less detail and in paler tones. Try painting onto pre-damped paper to enhance the misty effect given by distance.

▼ Willow
As with the pine, start the willow tree by putting in the knot holes and the split in the trunk, and then work the shape of the trunk in grey, varying the pressure and angle of your brush. Next, put in the main branches and draw some fronds, then add the black highlights, the darker fronds and some smaller, dark branches. Finally, run colour over the trunk and branches of the tree and use a large brush to put in wide bands of colour over the fronds, sweeping the brush downwards and tapering the strokes off the paper.

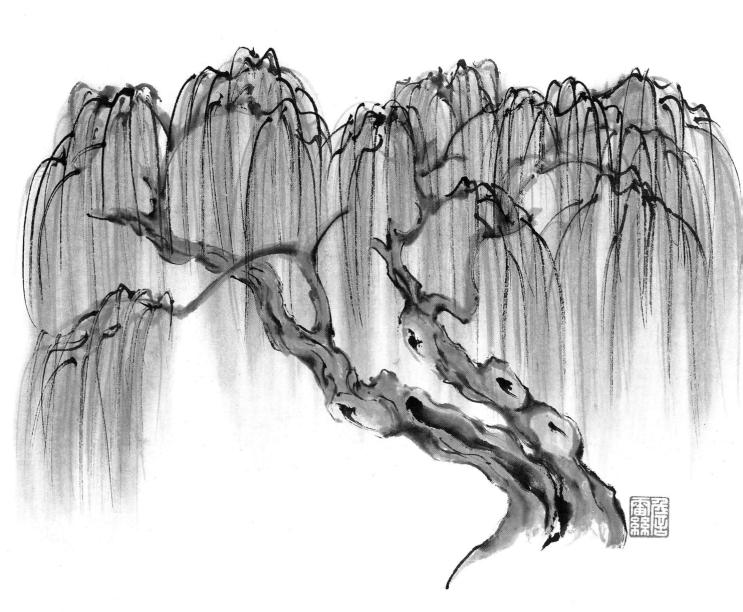

GROUND COVER

This page gives examples of some of the other kinds of plant and ground texture that you can use in landscape paintings.

▲ *To work ground texture, drag a coarse brush sideways across the paper.*

▲ *Create longer grass by laying the brush horizontally onto the paper and tapering it upwards.*

▶ *Work long grass or reeds in the same way as bamboo (see page 20), using a small brush.*

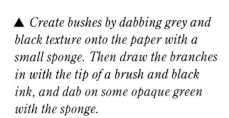

▲ *Create bushes by dabbing grey and black texture onto the paper with a small sponge. Then draw the branches in with the tip of a brush and black ink, and dab on some opaque green with the sponge.*

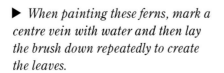

▶ *When painting these ferns, mark a centre vein with water and then lay the brush down repeatedly to create the leaves.*

You can build up a rock gradually in shades of grey and black or you can convey shape, texture and shading simultaneously. Whichever way you choose, remember to make every stroke relevant and to use as few strokes as possible. I usually find the build-up method, which is shown here, the most effective.

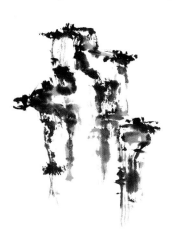

▲ *Build up the rock, first in grey ink and then in black ink.*

▲ *Once the ink has dried, damp the paper and bleed in some ink shading, remembering to keep water in the heel of the brush to avoid harsh lines.*

▼ *Leave the paper to dry before redamping it to wash in the colour, then blend thick Chinese green over some areas.*

MOUNTAINS AND HILLS

Mountains and hills consist of rocks, trees, shrubs or grass, or a combination of these, and it is important to be able to convey these differences.

You also need to be able to suggest that some features are closer than others. Obviously, size and the amount of detail you put into your painting are important for this, but you can also suggest greater distance by working in lighter tones. Make sure, therefore, that you use very vivid ink for the foreground, or you will not have enough scope with your tones and colouring to suggest different distances in your landscape.

▼ *Work the nearer mountain in the same way as the rock on the opposite page, adding an impression of trees at the base. For the more distant peak, fill three-quarters of the brush head with grey ink, keeping just water in the heel, and tip it with dark grey. Then press the full length of the brush head onto the paper several times.*

▼ *Do the tree-covered hill by pressing a large brush (filled as for the more distant peak in the example above) onto the paper, then roll it to form the shape of the hill. Create tree cover by repeatedly pressing a brush, filled with black, vertically onto the paper. The* colour should be added as a wash. Work the grassy slope by placing the brush, loaded as before, onto the paper and roll it, keeping the pressure as even as possible. Work the more distant hills in lighter tones on damped paper. Again, add the colour as a wash.

Buildings and other man-made structures in traditional landscape paintings were usually depicted from above, even if people beside them were shown from ground level.

Man-made structures were often given a firm outline and no shadow. My own theory is that this was done to emphasize the contrast between the beauty of natural phenomena and the rather flat, uninteresting character of man-made objects.

However, Chinese brush painting techniques are perfectly well suited to creating three-dimensional buildings and structures, and many modern painters pay as much attention to these as to rocks and trees.

▶ *These structures are typical of those found in Chinese landscapes. Use the tip of a brush to draw them, then add ink shading and colour.*

▶ *Structures can also be built up first in grey or colour and then in black. I have made some of these examples Western in character to show that this method can be applied to any shape. The reflection for the bridge was done on damped paper.*

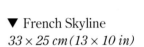

▼ French Skyline
33 × 25 cm (13 × 10 in)

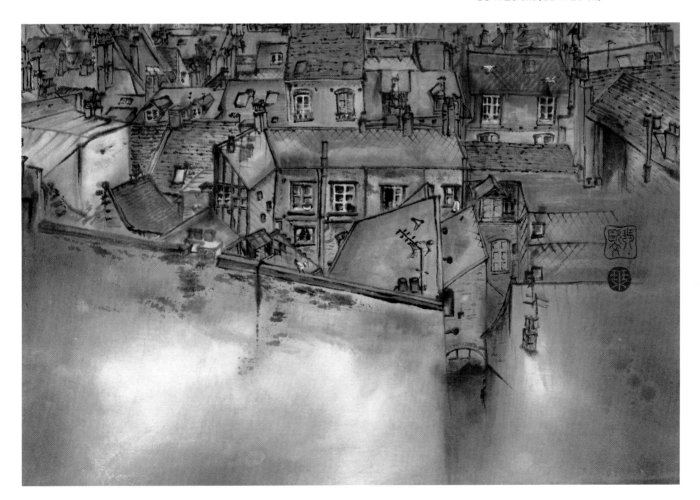

WATER

Although it is possible just to draw waves and clouds with the tip of the brush, I find this a very unsatisfactory way of conveying the fluid and ephemeral nature of these phenomena.

In my opinion, still water is most effectively suggested by simply putting in a reflection of the surrounding landscape features and then blending a little wash colour round the edge of the water, as shown in my example below.

Movement in water can also be drawn on and blended in as a wash. I did this for my painting (right), the kingfishers on page 5, and the ducks on page 39.

The water in a waterfall (below, right) needs very little definition. It is chiefly the shape of the rocks that creates the sensation of falling water.

▼ Still Water
29 × 43 cm (11½ × 17 in)

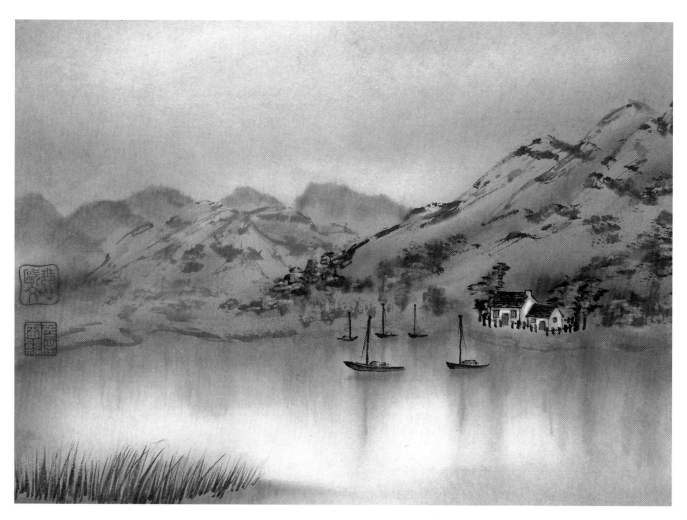

▲ Rough sea
I did the rocks in the normal way, then damped the paper before working the sea, highlighting the roughness by using gouache white – some of which I flicked on with the brush to create the spray.

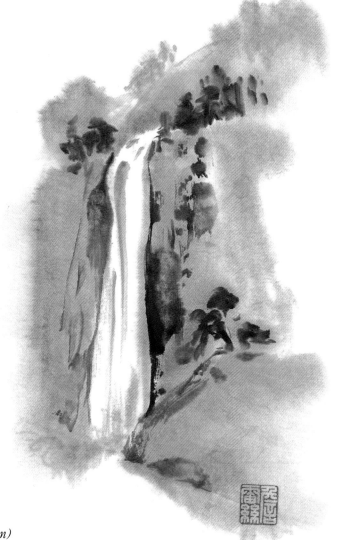

▶ Waterfall
29 × 19 cm (11½ × 7½ in)

SKY

Often sky can be suggested by the use of a fairly simple wash, creating lighter and darker areas. I did this for the painting of still water on page 60. By adapting the colours used, you can suggest different times of the day or changing weather conditions.

Cloud effects can be created rather like upside-down hills, as in the two examples on this page.

COMBINING THE ELEMENTS

My painting on page 63 combines as many of the elements I've already mentioned as seemed possible in a single picture!

I began with the foreground and worked back, completing the painting in ink tones before damping it to put in ink shading. I blended this outwards to create the misty effect, allowing the paper to dry before picking the main elements out with colour.

Once this had dried, I redamped the paper before painting the colour onto the middle ground and distance, blending it carefully outwards to enhance the misty feeling of the picture. I then washed in the colour for the sky and water, working carefully to create lighter and darker areas.

I added some light green highlights and then let the paper dry again before doing the birds and some more light green highlights in the foreground.

▼ *For a cloudy sky, work on wet paper and roll a suitably loaded brush (tip downwards) onto the paper, pausing and pressing in places. The effect can be softened by blending immediately with a clean wash brush.*

▼ *To create more diffuse cloud movement, give the sky area an even, thin white wash before rolling on the clouds.*

▶ Landscape
55 × 40 cm (21½ × 16 in)

MOUNTING

Once a Chinese painting is finished, it needs to be backed. This will bring the ink and colours fully to life, while also stretching and strengthening the picture.

Traditionally, Chinese paintings are mounted on special *shuan* paper. However, if you want to frame your pictures, I think that the easiest backing paper to use is watercolour paper which has a pressed weight of at least 285–300 gsm (140 lb) – anything less will buckle.

You can use wheat-based wallpaper paste, mixed to a loose 'dropping' consistency, or you can boil up your own glue, using ten measures of water to one measure of cornflour mixed with a pinch of alum.

MOUNTING TECHNIQUE

Cut your backing paper so that it is at least 50 mm (2 in) larger all round than your painting. Place the picture face-down on a clean, smooth surface and spray it lightly all over with water.

With your mounting brush (see page 9), apply glue to the back of the painting. Begin at the centre and work slowly outwards, adding a little glue at a time. Ease the paper gradually, working out creases and air bubbles as you go. Next, place the centre of your watercolour backing paper onto the centre of the painting and smooth the backing firmly onto the picture, working outwards from the centre and pushing out any air or excess glue.

Gently lift the backing paper and check that the painting is stuck to it before peeling it carefully off the table. Check the picture for air bubbles and gently ease any out from the front with a dry wash brush. Trim off all but a very narrow strip of the

▲ Gladioli
75 × 48 cm (30 × 19 in)

backing paper border and leave the painting to dry flat, face upwards. Don't worry if it buckles slightly. Once the picture is dry, trim off all the rest of the excess backing paper and flatten the painting under a sheet of board, stacked with weights.